COLD★WAR
WISCONSIN

COLD ★ WAR WISCONSIN

*To Jack & Jill
with warm wishes*

CHRISTOPHER STURDEVANT

THE History PRESS

Published by The History Press
Charleston, SC
www.historypress.com

Copyright © 2018 by Christopher Sturdevant
All rights reserved

First published 2018

Manufactured in the United States

ISBN 9781467140300

Library of Congress Control Number: 2018945796

Notice: The information in this book is true and complete to the best of our knowledge. It is offered without guarantee on the part of the author or The History Press. The author and The History Press disclaim all liability in connection with the use of this book.

All rights reserved. No part of this book may be reproduced or transmitted in any form whatsoever without prior written permission from the publisher except in the case of brief quotations embodied in critical articles and reviews.

CONTENTS

Preface	7
1. Cold War Origins	15
2. Operation Rollback: Insurrection Behind the Iron Curtain	29
3. The Day Under Communism: Mosinee on May 1, 1950	37
4. Joseph McCarthy: Hero or Pariah?	40
5. The Sky Is Falling: Sputnik IV Crashes in Wisconsin	44
6. Nuclear Missiles in Wisconsin: Project Nike	55
7. Cold War Casualties: Bombers Crash While Training Over Wisconsin Airspace	69
8. A Soviet Princess Takes Refuge in Wisconsin	76
9. USS *Pueblo*: A Small Kewaunee Ship Impounded in North Korea	80
10. Stasi Prisoners in Our Midst	87
11. A Safe House in Milwaukee	99
12. Cold War Personalities	104
13. Terror in Madison: Sterling Hall Explosion	109
14. Military Bases in Wisconsin during the Cold War	113
15. Legacy of the Cold War	118
Epilogue. The Cold War Abroad: Visiting Cold War "Battlefields"	121
Notes	135
Index	141
About the Author	144

PREFACE

WHAT WAS THE COLD WAR?

The name "Cold War" doesn't have the effect it once carried. Oftentimes during speeches and presentations, I receive puzzled looks and odd questions when discussing the longest and costliest conflict in American history. Where is the "Old" War Museum? Where is the "Cold Water" Museum? These questions, accompanied by blank stares, confirmed the need to educate not only a generation that had not experienced the Cold War but also many of those who lived through the era.

Anchored by two superpowers and their respective allies, the United States and the Soviet Union (Russia) stood toe to toe for forty-six years, waiting for the other side to blink and stand down. Since the first atomic bomb was tested and used to end the Second World War in 1945, both superpowers raced to yield more destructive weapons to outdo each other. What ensued was the threat and fear of nuclear war for decades during the Cold War and worries the world today. Both the United States and the Soviet Union set to dominate the land, air, sea and space, as those arenas would become the focus of outmaneuvering the other side. Alliances were formed in both the East and the West. On behalf of the West, the North Atlantic Treaty Organization (NATO) would be formed in 1949, forging itself in case of the very real possibility of Soviet attack. In response, the communists took hold of Eastern and Central Europe, forming the Warsaw Pact in 1955.

Preface

A conflict over Berlin broke out almost immediately when the Soviets blockaded that city in 1948. Like Germany itself, the city of Berlin had also been divided between East and West Berlin, with Soviet control over East Berlin and Allied control over West Berlin. Deep inside what became East Germany in 1949, Berlin was surrounded by hostility. Soviet leader Josef Stalin was determined to choke the city off from the Allies and force the Western powers out of Berlin. Through treaty at the Yalta Conference in 1945, the West had access to the Allied sector through roads and air corridors. Thus, through the air, the Berlin Airlift was born. For nearly a year, West Berliners were supplied with fuel, coal, medicines, foodstuffs and other supplies. Crisis was averted. The United States would not abandon West Berlin and its citizens. The Cold War was well underway.

Of course, the context of the Cold War is long gone, having been left to books about various historical events of the twentieth century and artifact relics in museums. It was an era when record players and rotary phones were high tech, James Bond worked covertly to stop the villains and being a superhero meant something like Superman's "peace, justice and the American way." The lexicon and symbols of the Cold War, not surprisingly, have changed as well. There is no Berlin Wall dividing that city, no longer an Iron Curtain across Eastern and Central Europe. Also absent are the high-level summits that took place, with the chattering class in Washington, D.C., talking up a peaceful approach to solving the Cold War. Nike today is a shoe company. Few would confuse that Nike with nuclear-equipped missile systems deployed around the United States to shoot down long-range Soviet bombers. Not to be forgotten, U2 is a famous rock band, not a spy plane, and a Bay of Pigs sounds downright cruel.

Humor aside, the Cold War's importance should not be underestimated, as it overshadowed and shaped our entire American way of life in the twentieth century and beyond. Militaries were sustained, diplomacy undertaken, foreign aid given to rebuild and sustain countries, weapons systems developed and even a national highway system was built in the United States. Preservation efforts and attention to this fascinating era is underserved, and proper recognition to the many millions of Cold War veterans has been lacking. Writing this book is a first step with that need in mind, especially telling the important local story of the Cold War.

The standoff between two standing superpowers sharpened after the Second World War; the United States and its allies stood toe to toe with the Soviet Union and its alliances in the world at large. Contrary to popular belief, the Cold War was anything but "peaceful." Nuclear war was the

potential outcome, a certain Armageddon that could destroy humanity. The Cold War was truly a world war, fought and challenged across the globe. Due to ever-increasing needs for information on the other side, the United States sent many dangerous missions behind the Iron Curtain. American planes were shot down over Eastern Europe, for example. Many men are still listed as Missing in Action from missions setting out to test response of Warsaw Pact radar systems. The Cold War was dangerous and deadly, fraught with conflicts from Asia to Africa, Korea, Vietnam and Angola.

WHAT HAPPENED TO THE COLD WAR?

I wondered this, curiously aloud at times, while looking around at the landscape of America in the early twenty-first century. America at that time was dealing with September 11, 2001, and its aftermath. As such, the United States was readying for war in Afghanistan to fight Al Qaeda, a group that directly financed the September 11 hijackers. As war plans in Afghanistan were being drawn up, phone calls were placed to Reagan-era Cold War officials involved in a prior war in Afghanistan: that country's long fight against Soviet occupation from 1979 to 1989. This would be the stepping-off point of America's fight inside Afghanistan, a war initiated by horseback and carrier pigeons in a high-tech age due to that country's remote and underdeveloped landscape. It beckoned the Cold War era that formed my life, an era that simply disappeared after the fall of the Berlin Wall in 1989. Two years later, the Cold War whimpered to a close with the subsequent dissolution of the Soviet Union in 1991. No ticker-tape parades took place. No wide-scale celebrations in the streets. No Nuremberg Trials like those after the Second World War were convened for war crimes on the defunct Soviet Union and its Warsaw Pact alliance. Time simply kept marching along, as if the Cold War never really occurred here in the United States.

REMINISCING: A COLD WAR CHILDHOOD IN WISCONSIN

I could not have been further from the Cold War if I tried. But as a curious child of the Cold War era, I grew of age in the 1980s reading newspapers, magazines and countless atlases while studying the world. Current events,

history, math and geography were of high interest. If not for being active playing sports, both in the neighborhood and at school, these topics would likely have made me the most uninteresting kid around. And as I continued to be exposed to developments of the day, few people around me seemed to have either the interest or answers to questions percolating in my young brain. It was up to me to find out and put the pieces together. Passions were stoked at a young age and would follow me well into adulthood. Little was I aware just how far my search into the Cold War would take me to places such as North Korea, Chernobyl and Afghanistan in the twenty-first century.

In Janesville, a city surrounded by farming communities, rumors abounded that a local company called the Accudyne Corporation was housing nuclear material. It turned out, many years later, that this assessment was correct. We watched movies such as *Red Dawn*, *Damnation Alley*, James Bond films and, of course, *Rocky IV*, where Rocky Balboa takes on the Soviet Ivan Drago inside Russia. These movies convinced us of America's superiority to communism or an ability to survive war/nuclear war with the Soviet Union and its proxies. Curiously, there were no similar movies created in the Soviet Union. To have such a notion of American power was off limits.

On a larger scale, however, the dominant foreign policy in the late 1970s was with the Soviet Union and Iron Curtain countries. That geographic and political reality grabbed my attention right away. I recall faint memories of the Winter Olympics in 1980, when the United States defeated the Soviets in hockey, dubbed the "Miracle on Ice." Years later, I would be traveling in Finland, and a fellow Rotary member in Jyvaskyla reminded me that the United States defeating Finland in 1980 for the Gold was not forgotten. The unbelievable showing in hockey was followed closely by an American boycott of the Moscow Summer Olympics due to the Soviet invasion of Afghanistan. Moscow, as depicted on television and the news, was clearly a dreaded place by all standards, based on gray, stoic and lifeless people in a barren, cold landscape illustrated daily. Long lines for consumer goods were a fact of life for Russians, I presumed, standing in line waiting for such basic staples as bread. I would later learn that this was partially due to no use of preservatives for bread, as it would go stale quickly. Grocery stores with ample selection of foods were a simple drive down the road where I lived. At a young age, I could grasp that there was something different between our two countries.

Preface

WHAT ARE THOSE SOVIETS UP TO?

Soviet leaders were dying off like dominoes. First Leonid Brezhnev in 1982, followed by Yuri Andropov in 1984 and then Konstantin Chernenko in 1985 before Mikhail Gorbachev assumed power. I scratched my head wondering why these leaders kept dying off. In retrospect, Ronald Reagan was asked by the press why more summits with the Soviets didn't occur. Reagan responded that he wanted to, but they kept dying on him.

One of the most distinct memories I had as a nine-year-old was reading about a place in Europe called Poland. As I became more fascinated about this geopolitical world, I read about martial law being imposed on civilians by that country's military leader and wondered what was going on. Why would people in these cities be under a curfew? As a nine-year-old boy, I had a curfew, but it was imposed by my mother and not a military general.

That episode of history was a movement called Solidarity, which was taking place in the shipyards of Gdansk, Poland. Protests broke out, dissidents or those aiding the Solidarity movement were arrested and detained and the Soviets threatened to move into Poland unless the communist-backed Polish government did something about it. The events in Poland in 1981 would form the basis of my Cold War interest many years later. Lech Walesa, a leader of the Solidarity movement, would eventually become president of Poland in 1990 after the fall of the Berlin Wall and breakup of the Iron Curtain countries within Soviet grasp.

As I continued to grow up during the 1980s, I witnessed Reagan's presidential election, and his tough talk about the Soviets was always in the spotlight. There wasn't a day that went by as Reagan took it to the Soviets. His talk of the Evil Empire and proposing a Strategic Defense Initiative in 1983, supporting technology to shoot down incoming nuclear missiles, sparked not only my own but also the nation's imagination. Reagan visited the Soviet Union in 1987, shaking hands with one Vladimir Putin in Red Square during his visit. Earlier that year, when standing near the Brandenburg Gate adjacent to the Berlin Wall, Reagan asked Mr. Gorbachev to "tear down this wall!" To many people's amazement, it fell in 1989; I could only bear witness to the event on a television screen. The Soviet Union sat motionless and did not invade with tanks, unlike in decades past, as nations behind the Iron Curtain one by one would claim their own sovereignty. The Soviet Union would dissolve in 1991. Shortly thereafter, I watched George H.W. Bush give

Preface

a speech to the Polish Duma in 1991. What started my fascination from 1981 in Poland gave rise to the beginning of a post–Cold War world. In many respects, we are still living in one today.

WHAT THIS BOOK IS ABOUT

When confronted with the idea of the Cold War, I asked two distinct questions. First, what were the origins of the Cold War? Secondly, what was the local impact? Geographically speaking, the United States was far away from the events unfolding around the rest of the world after the Second World War. Short of those serving in the armed forces; those with relatives in world zones especially hit such as Europe, Asia or Latin America; or those spending extended time abroad, many Americans were not directly affected by the Soviet Union and its reach. Thus, as Americans, too often we thought of the Cold War as ephemeral or occurring somewhere else: Berlin, Cuba, Vietnam, Korea and so on. But where did the men and women who served in the U.S. armed forces come from? Where did Cold War munitions, trucks, ships and other war support initiate from? How about our politicians, diplomats and others who would figure so prominently in many Cold War events?

After all, it was Joe McCarthy unmasking communists in Washington, D.C., and Douglas MacArthur leading the charge in Korea in the 1950s. Badger Army Ammunition and the Amron Corporation were manufacturing propellants to support our troops for wartime, and Nike Hercules nuclear-equipped missiles were deterring a Soviet bomber invasion in Wisconsin. Each of these Cold War entities had local connotations. Notably, our military personnel and politicians came from somewhere, and defense plants employed workers who made war material someplace.

Thus, Wisconsin was at the forefront of the Cold War. A famous politician once said that all politics are local; the Cold War was too. Eight Nike missile systems were deployed in the Milwaukee area alone. Joe McCarthy and Douglas MacArthur called Wisconsin their home. George Kennan from Milwaukee authored the Containment Policy, which was the framework of U.S. foreign policy for nearly sixty years. Kewaunee shipyards produced the USS *Pueblo*, the Badger Ammunition plant produced propellants in Sauk Prairie and shell casings and ejection seats were made at the Amron Corporation in Waukesha. Servicemen from the upper Midwest were even

Preface

sent to the Russian front during World War I, fighting the early Bolsheviks and the Red Army during the Russian Civil War in 1919. Tying these events and personalities together is a challenging task, a jigsaw puzzle.

This book is meant to be a thought-provoking look at our Cold War heritage right here in Wisconsin, examining our ties to the larger struggle between the United States and the Soviet Union. It is not meant to be the definitive work, since it is written oftentimes in an anecdotal sense, picking up stories from a patchwork of friends and acquaintances who have been invaluable during their own experiences in the Cold War era. In some cases, these stories are unknown and have not been told until now, especially in context with the plethora of Cold War history occurring right here in a midwestern state. Prominently, an underlying theme of this book is also a journey of discovery. In the conclusion, I hope to share with the reader how the Cold War legacy continues here and around the world—how this author, a south-central Wisconsin boy, grew up to connect with passions. Inadvisably visiting fascinating yet dangerous Cold War legacy countries has been an amazing endeavor. In the end, I sincerely hope that you, the reader, will find this work enjoyable and interesting, perhaps even recalling this fascinating history for those who lived through the latter part of the twentieth century.

Special thanks to John Rodrigue of The History Press for reaching out to me to write this book. Gratitude also to my project editor, Ryan Finn, as well as the marketing and sales staff. Tremendous gratitude to friends, family, coworkers and Cold War colleagues for the support throughout this endeavor.

CHAPTER 1
COLD WAR ORIGINS

AN ERA BEGINS WITH POLAR BEARS

The story of the origins of the Cold War is a unique telling in and of itself. Ask ten economists their opinion and you will receive eleven different answers. Similarly, ask historians or students of history "when" the Cold War began or ended and multiple answers emerge as assigned possibilities. Premises of the Cold War would suggest that the fruits of the Cold War were sown at the Yalta Conference in 1945, a military standoff with the Berlin Blockade and Airlift in 1948–49, or the moment the USSR conducted its first nuclear test in 1949, igniting a nuclear arms race between the superpowers. Other insightful research suggests that the beginnings of the Cold War were initiated as an American B-29 was forced down by Soviet fighters over northern Korea on August 29, 1945.[1] Taken as a whole, these are but several answers to the many facets of the Cold War with the Soviet Union. None of these answers is incorrect, and this offers both the master and apprentice a Cold War era up for tremendous debate. What Polar Bears have to do with the origins of the Cold War will be unraveled in the following pages.

The fascinating saga of the Cold War follows a rather interesting arc during the twentieth century. To be clear, the modern Cold War was certainly a vestige of the Second World War. The Allied powers, out of necessity, included the Soviet Union during the Second World War. In June 1945, the big three Allied powers of the United States, Great Britain and the

Soviet Union met in Yalta one final time during the war to draw up postwar maps and assign spheres of influence around the globe. Due to espionage employed by the Soviets and British, a not-so-well-kept secret between the three powers was the advanced stage development of an atomic bomb by the United States. By August 1945, two atomic bombs would be dropped on the Japanese cities of Hiroshima and Nagasaki. Distrust was well underway, and the Second World War would soon make way for the Cold War.

During those tumultuous days of the war's end, both the Americans and Soviets rushed to glean scientists from defeated Germany to perfect Nazi rocket designs, build supersonic aircraft and help create, test and deploy atomic weapons. During Operation Paperclip, the United States would capture an enterprising young engineer named Wernher von Braun. He and other former Nazi engineers and scientists would eventually shape the United States space program. The acceleration of the space program would become established by the Soviet Union's launch of Sputnik in 1957, the first man-made satellite in space.

Espionage and information would become a key weapon in fighting the Cold War. Suspicions had already supposed that a post–World War alliance between the United States and Soviet Union would not likely exist. Milwaukee native George Kennan, a relatively unknown diplomat to Americans at the American embassy in the Soviet Union, concluded such in his famous "Long Telegram," describing the mood inside the Soviet Union in 1946.[2] Information on the other side's progress in a quest for domination could mean the difference between life or death for military participants and civilians alike. Thus, the Second World War would sow the seeds of intimidation, harassment and testing each other's will by exploiting strengths and weaknesses all over the globe for decades during the twentieth century.

FIGHTING IN THE COLD: AMERICAN TROOPS ARE SENT TO RUSSIA

For those of us too young or not yet born at the time, it is difficult to imagine witnessing world war only to see the dawn of another. The tragedy of the Cold War began under the cloud of a war whose vast scope and brutality was unprecedented, ravaging the European continent for what seemed an eternity. Millions of lives were lost as new weapons of devastating destruction were created and utilized on the battlefield and on civilians. Even as Allied

victors determined postwar boundaries, it was a dire time for millions who had endured starvation, homelessness and unsanitary conditions. Europe was ripe for revolution and occupation; the emboldened communist snake in Russia was ready to strike on a worldwide level.

Hence the story of the Cold War unfolds. Winston Churchill decried godless communism, while an early "Iron Curtain" was described as descending on and across Europe. A "Red Scare" started like a wildfire in the United States, sending the population into a frenzy. War veterans of the American Legion swore an oath to "foster and perpetuate a 100% Americanism." Various adherents to communism, socialism and anarchism were rounded up, arrested and jailed. From his perch in the U.S. Justice Department, a young J. Edgar Hoover identified these suspected communists in America, going so far as to deport a significant number of those suspected to Soviet Russia. In the final months of the "war to end all wars," a division of five thousand American troops mistakenly believed that it was being sent to the front lines of Europe. Instead, the men found themselves in a desolate and frightening place never imagined: bitterly cold North Russia. Some eight thousand American servicemen were also deployed to Vladivostok in Siberia. Soon these troops would come face to face with the Red Army.

The Great War was drawing to a close; it was 1918.

POLAR BEARS AND THE ALLIED INTERVENTION INTO THE RUSSIAN CIVIL WAR

Winston Churchill, known to most as a prime minister of Great Britain during the Second World War, was one of the first to foresee the danger and damage that communism was capable of inflicting on the world. As a minister of munitions and then secretary of state for war, Churchill in 1919 was very clear when stating that Bolshevism should be "strangled in its cradle."[3] Like his actions and stance against the rise of Nazism a generation later, everything in his power was laid bare in confronting Soviet communism early on. The world was shocked to its core when the Bolsheviks, led by Vladimir Lenin, Josef Stalin and others, ousted the Russian Provisional Government led by Alexander Kerensky in 1917. Not only did the Allies of the First World War lose an important, strategic nation in confronting the kaiser's Germany, but communist ideology also threatened world order. The militant brand of socialism espoused by these Bolsheviks declared war

Winston Churchill, advocate of the Allied Intervention into North Russia in 1918. *Library of Congress.*

on every country that embraced capitalism, laissez-faire attitudes, liberties and other tenets that hold together democracies and republics. Hence an intervention into Russia was drawn up. The British then recruited other nations to partake in the crusade to strangle Bolshevism in its cradle.

As assistance was asked of Woodrow Wilson to take part in the Russian intervention, all the American soldiers in North Russia and Siberia were placed under command of the British. This fact was not lost on these American troops. Soldiers who held strong feelings about this chain of command would often vocally remind their superiors of the incurrence of taking orders from a nation that America had fought against for its own freedom dating back to the Revolutionary War and War of 1812. To make matters worse, American soldiers were issued Russian rifles upon arrival. The guns often jammed and were inaccurate against an enemy they knew little about in a foreign place.[4] Bad weapons, sickness, cold frigid weather and a population that didn't support the interventionists made for a bizarre episode in a strange, alien place.

Wisconsin ties were crucial in this seminal world event, as from a local perspective, many of the soldiers sent to North Russia were from the Midwest. As the Polar Bear Expedition Digital Collection site summarizes succinctly:

During the summer of 1918, the U.S. Army's 85th Division, made up primarily of men from Michigan and Wisconsin, completed its training at Fort Custer, outside of Battle Creek, Michigan, and proceeded to England. While the rest of the division was preparing to enter the fighting in France, some 5,000 troops of the 339th Infantry and support units (one battalion of the 310th Engineers, the 337th Field Hospital, and the 337th Ambulance Company) were issued Russian weapons and equipment and sailed for Archangel, a Russian port on the White Sea, 600 miles north of Moscow.[5]

These soldiers would survive a journey full of sickness into the Arctic regions of Russia, only to find themselves thrust into battle with Bolshevik forces in faraway Archangel and Murmansk in 1918–19. Archangel and Murmansk are two of only a few Russian port cities accessible by ship on the coast of the Arctic Circle. These men would join forces with not only British forces but also Canadian, French, Polish and other nationalities fighting the Red Army. Most would find themselves fighting along railways, riverways and other corridors that the Bolsheviks would challenge to fight the invading forces.

On a separate front, several time zones from the North Russian Arctic forces, other Wisconsinites would deploy to Vladivostok in Siberia on the Pacific coast. These men would also join a diverse group of interventionists from many countries. For a variety of reasons, as well as self-interest, tens of thousands of Japanese, French, British Commonwealth, Chinese and others would intervene to fight on the battleground of far eastern Siberia. American troops would take up defensive positions in that region, operating the Trans-Siberian Railroad and guarding rail lines along the Pacific coast in that country. The Allied Intervention on all fronts would throw most of its support to the White Armies battling for control with the Bolshevik forces over the fate of Russia during the Russian Civil War.

One prominent Wisconsinite deployed to North Russia was John Cudahy. Cudahy was born the son of Patrick Cudahy, a namesake that continues to grace bacon, kielbasa, sausages and other meat packages throughout grocery stores in the Milwaukee area and beyond. In 1918, John Cudahy was a first lieutenant in the 339th Infantry regiment with Allied Expeditionary Forces sent to North Russia. In his book *Archangel: the American War with Russia*, Cudahy was openly critical about the experiences of the Allied Intervention into Russia. An inadequate force intervened, the interventionists underestimated the opposing Red Army, the local

Men from the 339th Infantry in Archangel, North Russia, 1919. *Library of Congress.*

population did not support the effort and there was no moral fortitude toward victory.[6] As Cudahy pointed out, despite the bitter cold, men from northern Wisconsin and the Upper Peninsula of Michigan did not mind the severe weather. The troops were given adequate warm fur coats and blankets.[7] The issue with the intervention became clear when the snow settled in, and offense maneuvers were limited due to snow in the alien country and hostile attitudes of the locals. John was battle tested early on November 11, 1918, when the lieutenant attacked one thousand Bolsheviks holding the village of Tulgas on the Northern Dvina River.[8] John Cudahy would go on to serve as an ambassador to Poland and Belgium, as well as representing diplomatic ties to Luxembourg and Ireland. Without discussing his own role in the faulty campaign, he outlined several reasons for its failure. The Patrick Cudahy Company continues to be a strong local company headquartered in Cudahy, Wisconsin.

WHY WERE THESE SOLDIERS IN SUCH FARAWAY REGIONS?

Ostensibly, troops in both North Russia and Siberia had several goals to meet as their objectives. The first order of business in North Russia, as the First World War continued to rage in Europe in 1918, was for troops to immediately fortify an eastern front from which the newly minted Russian Bolshevik government withdrew in 1917. After suffering a series of losses by the kaiser's German armies, the Treaty of Brest-Litovsk was signed. Immediately, German forces would be able to concentrate on the Allied advances in the west, much to the consternation of Allied commanders in France and Britain. As a hedge against the German and Japanese forces, however, local Soviets in both North Russia and Vladivostok welcomed the Allied interventionists since Russia no longer had a potent, if any, force to protect itself from invasion from east or west.[9]

Other goals of the Allied interventionists would be to protect and procure Allied armaments and supplies sent to the Czarist government during the First World War. Supplies, foodstuffs and other materials to secure

United States troops in Vladivostok, Siberia. *Library of Congress.*

and enhance the prior Czarist military from Germany's assaults on the eastern front were conceivably in storage, and the Allies wanted neither the Germans nor the Bolsheviks to gain control of them. Yet another reason would be to allow Czech troops safe passage to exit Central Europe via the Trans-Siberian Railway en route to Siberia. During the First World War, Czech troops, guided by their own self-interest of independence, joined Czarist Russia in fighting the Axis powers. The Axis powers included the Austro-Hungarian empire, overseeing the lands that the Czechs, Bohemians and Slovaks inhabited, places that preferred independence. Toward the latter part of the war, these Czech Legion troops were caught between the Germans and Bolsheviks and sought a way out of the region to join up with French troops. An agreement was made to allow these troops passage east to Vladivostok. During their painstakingly slow movement east, they encountered and fought Bolshevik troops. The Czech Legion was perhaps the strongest group fighting in the Russian Civil War, taking charge of the Trans-Siberian Railway as it fought its way out. President Woodrow Wilson was hesitant to send any men to Russia or Siberia but acquiesced based on these goals.

FIGHTING AFTER VERSAILLES: THE RUSSIAN CIVIL WAR

The First World War ended on November 11, 1918, with an armistice signed at Compiègne in France. However, the treaty did nothing to conclude the war aims of the interventionists in North Russia or Siberia. Even if the treaty had included those men who served in both theaters, those troops were trapped by Arctic sea ice formations in the Archangel and Murmansk region. There was no way to extract these men and bring them home, even if they were recalled from battle by decree by their respective governments.

As noted, in the early stages of arrival, the interventionists were welcomed and invited by local Russian leaders to take up positions in North Russia. The threat of the German advance was still present, and the Bolsheviks, having immediately and swiftly dismantled the Czarist military, were useless in defending their own territory. These men who made up the Allied Intervention thoroughly believed in the mission to expel the communists from power. Many, however, would question their usage in

a war that was not adequately managed and had shifting priorities as the intervention went on.

Once the First World War ended with the armistice, a different set of priorities ensued. In 1918, the German kaiser abdicated and consequently was defeated, and Russia no longer had a threat of invasion on its territory on the eastern front. Using the interventionists to hedge against further invasion of Germans into Russia was no longer necessary. Attempts to oust these armies that had overstayed their welcome ensued by the Bolsheviks, and a campaign to create the Red Army for the new Soviet Russia was undertaken by Leon Trotsky.

Another goal of protecting stocks sent and stored by Czarist Russia was also rendered obsolete by the interventionist forces. Armaments, food stocks, fuel supplies, blankets and other items sent to assist the Czarist war efforts were pillaged by locals and storehouses abandoned by the time the Allies reached the North Russian port cities. By all accounts, the Czech legionnaires were doing quite well on their own. As Winston Churchill continued to advocate "strangling" the Bolsheviks in their cradle, the goal of defeating the Bolsheviks early in their tenure was haphazardly followed. With ice blocking soldiers' exit, and at the mercy and transportation of the British, the wishes of the British command were the final word. Soldiers in the 339th Infantry and other units intervening would spend many more months fighting the early Red Armies.

Going on the offensive, the intervening armies of North Russia would undertake operations against the Red Army during the cold winter of 1918–19. They would push the Red Army south along rivers and railroads. White Armies would be loosely affiliated, yet uncoordinated, in fighting across Russia, Siberia and border countries countering the Bolshevik armies. In total, American troops would suffer 235 deaths while serving in North Russia over a nine-month period. Taking a different approach, the United States troops under General Leslie Groves in Siberia would not undertake offensive missions in Siberia, much to the chagrin of his British counterparts. Groves's preference was taking defensive postures and adhering to the original goals of guarding stocks of armaments and supplies sent to the Czarist government during the First World War. American troops would depart Siberia in 1920 after suffering 189 deaths from all causes.

War weariness was setting in for Americans at home. The Versailles treaty was signed, and the Great War had completed its bloodletting. Questions were raised as to why these soldiers were fighting in a war halfway across the

globe in a Russian Civil War that had no effect on those at home. Letters were written to congressmen to allow their fathers, brothers and siblings to come home from Russia and Siberia. A Republican senator and noted progressive, Robert "Fighting Bob" La Follette from Wisconsin, took the lead in demanding American soldiers come home. Coincidentally, Senator La Follette (and others in his namesake) was accused in later years as being soft on communism and being sympathetic to socialist causes. A generation later, Robert La Follette Jr. would be challenged by an upstart Joseph McCarthy in 1946, essentially losing to the senator who would make his name on identifying the Red Menace within our midst. American soldiers fighting in Russia would stage their own protests; morale was low, and the effort to intervene inside Russia was slowly failing. An agreement was reached to bring the boys home.

When spring arrived and the ice melted, American soldiers were relieved by British soldiers, who would continue their quest to ally with White Armies and expel the communists. Eventually, the British government refused to carry on the war inside Russia, citing war weariness and costs of underwriting the expedition. In 1920, Moscow was encircled by opposing White Armies and interventionists to the east, west and south. But the failure to fund the efforts of the White Armies, along with lack of coordination among the opposing forces, allowed this entire effort to collapse. The Bolsheviks were successful in ousting the interventionist forces and building a new Soviet empire. Propaganda, always a strong suit with these Soviet progressives, would be used well, highlighting the failures of these foreign interventionists expelled by the Soviet Red Army. It would be another seventy years before the Soviet Union would cease to exist, putting subsequent generations under oppressive regimes under the fallacy of utopian equality.

POLAR BEARS

With orders of withdrawal secured, the men of the 339th Expeditionary force returned home to their base in Detroit, Michigan. After suffering in the frigid cold for many months, a significant number of men contracted the Spanish flu. An untold number died during the voyage home. Upon returning, the men voted to call themselves "Polar Bears." They were authorized to wear a patch with a symbol of a polar bear signifying their

fight and experience in frigid North Russia. Several hundred men were buried and left behind in North Russia; an effort was underway to bring back remains. Lack of diplomatic recognition made returning to North Russia to secure the remains of American service personnel buried in the Arctic landscape almost impossible. Ten years later, in 1929, a group of men who fought in North Russia would return to those battlefields to identify and bring back 226 men who died and were buried while fighting the Bolsheviks. The Veterans of Foreign Wars (VFW), along with a $15,000 grant from the Michigan legislature, helped underwrite and guide the trip back to the frigid domain.[10] To this day, 128 men are still unaccounted for and Missing in Action (MIA) in North Russia.

POSTWAR AND INTERWAR PERIOD

Seeing Red: The First Red Scare of 1919–20

Most Americans learned and continue to use the catch-all names of Joe McCarthy and McCarthyism as derogatory terms for hunting enemies in their midst and destroying reputations. Few would connect the first Red Scare with the events of Bolshevik Russia taking shape in 1918 as American sympathizers of the Soviet movement were gaining adherents at that time. As troops were returning from the Arctic Circle, an organization close to my heart was taking shape. (I am a lifetime member and former commander of American Legion DJ Martin Post 8 in Waukesha, Wisconsin.) The American Legion was created by veterans of the First World War and chartered in 1919 as a patriotic veterans service organization by the United States Congress. The Red Menace created an extraordinary sense of anxiety among the public, and these members returning from war were eager to do their part in defending American idealism. Hence, the American Legion included in its charter the promise to "uphold and defend a 100% Americanism" in its preamble.[11] To this day, the same preamble is spoken and referenced at every meeting and convention held by the American Legion in the United States and abroad.

Back on the homefront, a young J. Edgar Hoover was making his mark against the Red Menace as well. Labor unrest was being fomented by communists, anarchists and socialists. Bombs were being sent to various political figures, with deaths and dismemberment common in those

violent incidents. As a result, a hard line against radicals and subversives in the United States was undertaken. Various suspects adhering to un-American activities were targeted during the Red Scare in 1919. Raids were authorized by A. Mitchell Palmer, then Justice Department head. The question became what to do with these radicals who were deemed harmful to United States interests. Perhaps if these radicals loved communism so much, why not let them live in Communist Russia? That indeed was what happened, and it was determined that these individuals would become "Christmas presents" for Lenin and Trotsky. In December 1919, a ship commissioned as the USS *Buford* was utilized by the United States Navy to send these "presents" to Bolshevik Russia. Using intermediaries, some 249 souls from the United States were sent for a three-month voyage to Finland (since there was no diplomatic recognition of the new Bolshevik Russia, the members of the Soviet Ark were dropped off in Finland). It was at the Finnish border with Russia where these radicals and self-identified communists would walk into the Soviet Union. The Soviets, never shy about pomp and circumstance in these situations, greeted these "Christmas presents" with cheers and a big band reception playing the Russian national anthem. The 249 members of the Soviet Ark had been hailed as heroes for upholding communist beliefs.

The most famous passenger was Emma Goldman (Lithuanian by birth), who was lecturing in Chicago at the time she was notified of her deportation to Red Russia. Goldman was arrested many times over the years for fomenting labor unrest and promoting socialism and anarchy in the United States. Most notably, Emma Goldman was linked to a violent protest in Chicago called the Haymarket Affair in 1886. In her book *My Disillusionment*, Goldman could barely contain herself while experiencing emotions of finally being in revolutionary Russia: "I could sense the awe and humility of our group who, treated like felons in the United States, were here received as dear brothers and comrades and welcomed by the Red soldiers, the liberators of Russia."

Unfortunately for Emma Goldman, her idealist views of communism—obliterating classes of wealth and championing the working class, thereby entering a new world of idealism—never materialized. She would find herself under house arrest and fled Soviet Russia after nearly a year in the country. After living abroad, she died in Toronto, Canada, in 1940. Emma Goldman is buried alongside other Soviet sympathizers at the Forest Home Cemetery near Chicago in Forest Park, Illinois.

Interwar Period

After the Russian Civil War ended with the defeat of the White Armies and the withdrawal of interventionist troops, Bolshevik Russia under Josef Stalin consolidated its power over neighboring republics. The Union of Soviet Socialist Republics (USSR) was formed in 1922, eventually annexing to form eleven republics and going on to encompass eleven of the world's twenty-four time zones. During the 1930s, some Americans even went to live in the Soviet Union. These people were willing to escape the Great Depression for the promise of jobs and housing. Americans were also excited to join such a futuristic and wonderful concept that promised equality among all and no racism. One of these men was John Scott, who left the University of Wisconsin–Madison in 1931. John would become a laborer for the Soviet city being built called Magnitogorsk. In his book *Behind the Urals: An American Worker in Russia's City of Steel*, John would detail nearly a decade of his living and working inside the Soviet Union.[12] There was considerable zest among those creating Magnitogorsk, and workers believed that the Soviet Union represented the future. John nearly got caught up in the purges alongside other foreign-born citizens in the Soviet Union. He had great difficulty leaving the Soviet Union, due to the fact that his wife and children were wanting to leave that country as well. They would all leave in 1942 and head back to the United States.

Diplomatic recognition was given to the Soviet Union in 1933 by the United States under Franklin Delano Roosevelt. FDR's New Deal administration attracted persons who felt that the common man had been forgotten. But the new administration also attracted those who felt the same way as many idealists, fond of the Soviet system of government and the future as central planning. Influential advisors and consultants such as Harry Hopkins, Harry Dexter White, Alger Hiss, Owen Lattimore and others accused of communist connections and having ties to the Soviets would be identified long after the Cold War had ended by the Venona Decrypts. Moreover, much of the American enthusiasm for communism was soured upon learning about the purges and show trials taking place inside the Soviet Union. American communist sympathies were further strained by Soviet-Nazi relations on the eve of the Second World War, when the Soviet Union and Nazi Germany signed a non-aggression pact. The non-aggression pact included partitioning of Poland, which would lead to the Katyn Massacre of Polish officers, clergy, property owners

and other Polish leaders by Soviet troops in 1940. Immigrants of Polish descent who had moved to Milwaukee would never forget this moment of Soviet-Polish history. The Second World War would see an uneasy alliance formed between the Soviet Union and the United States, one that would not last beyond the common defeat of Adolf Hitler and Nazi Germany.

CHAPTER 2

OPERATION ROLLBACK

INSURRECTION BEHIND THE IRON CURTAIN

After the Second World War, Americans were happy to be relieved of the world conflict. More than 16 million Americans served during the Second World War. Americans were fortunate to have not had warfare occur on the continental United States. Save for an island landing on the Aleutian Island chain of Alaska by the Japanese, as well as several unexploded Japanese balloon bombs sent over the Pacific on American soil, the United States largely escaped unscathed. There was no destruction, no ruin, no political upheaval, and society was largely stable untouched by warfare.

The state of America was contrasted sharply with Europe. Untold tons of firepower through mortars, rockets and aircraft, as well as fighting between millions of advancing troops, left Europe in ruins. The rebuilding had barely gotten underway before the Cold War began. Europe was ripe for communist takeover and entrenchment. And as American troops withdrew from Europe, the Soviet Union stayed in countries where it had advanced. Despite promises at Yalta, Josef Stalin and the Soviet Union were promoting and setting up communist governments throughout Central and Eastern Europe, accountable to Moscow.

As he did in the infancy of the Soviet Union in 1918, Winston Churchill took the lead and warned of Soviet dangers. After being voted out of power the year before, Churchill went on to give a famous 1946 speech at Westminster College in Fulton, Missouri, where he noted Soviet communism on the march:

From Stettin in the Baltic to Trieste in the Adriatic an iron curtain has descended across the Continent. Behind that line lie all the capitals of the ancient states of Central and Eastern Europe. Warsaw, Berlin, Prague, Vienna, Budapest, Belgrade, Bucharest and Sofia, all these famous cities and the populations around them lie in what I must call the Soviet sphere, and all are subject in one form or another, not only to Soviet influence but to a very high and, in some cases, increasing measure of control from Moscow. Athens alone—Greece with its immortal glories—is free to decide its future at an election under British, American and French observation. The Russian-dominated Polish Government has been encouraged to make enormous and wrongful inroads upon Germany, and mass expulsions of millions of Germans on a scale grievous and undreamed-of are now taking place. The Communist parties, which were very small in all these Eastern States of Europe, have been raised to pre-eminence and power far beyond their numbers and are seeking everywhere to obtain totalitarian control. Police governments are prevailing in nearly every case, and so far, except in Czechoslovakia, there is no true democracy.

During the waning days of the Second World War, Churchill asked for a contingency plan to invade Soviet-occupied Europe on July 1, 1945. Operation Unthinkable would include forces of England, the United States and Poland that would work to wrest the Soviet troops out of Europe and liberate those countries from communism. With food, supplies, fuel and other commodities in short supply, there was little chance the plan would succeed. War weariness was abundant, and there was little excitement for a protracted war against the Soviet Union. As the Cold War took shape, Operation Unthinkable would be utilized for planning a contingency war should a third world war break out with the Soviet Union.[13]

MILWAUKEE NATIVE SETS AMERICAN FOREIGN POLICY

In the meantime, a native Milwaukee diplomat named George Kennan, deputy chief of mission at the United States Embassy in Moscow, issued a cable to Washington, D.C., in 1946. The cable would outline and highlight the Soviet outlook in the postwar period and how to combat Soviet communist advance. This "Long Telegram" would become the United States' basic foreign policy against the Soviet Union and the world for nearly sixty years.[14] The

Long Telegram would be summarized and published in *Foreign Affairs* in July 1947 as "The Sources of Soviet Conduct."[15] Kennan's article, signed as "X" for anonymity, would outline and formulate the Containment Policy. Containment would come to be defined as taking on the Soviet Union and communist expansion through less direct methods other than warfare between the two superpowers. However, containment would also lead to accepting the existing fate of millions of citizens inside countries behind the Iron Curtain in Europe. To solve that problem, Kennan and others would develop Operation Rollback.

George Kennan, author of the American Containment Policy. *Library of Congress.*

As the Containment Policy was being formulated, something needed to be done quickly to help Europe's construction efforts and deny communist gains in those countries. Harry Truman and Secretary of State George Marshall devised a plan designed to give aid and rebuild Europe and other devastated nations. It was a plan and economic offering keen to keep the communists from gaining power in Europe as well. Communist parties were strongly active in Italy, Greece, France and other nations of Europe. The Economic Cooperation Plan passed the United States Congress in April 1948.[16]

In order to disburse and accept foreign aid to rebuild their economies and infrastructure, countries had to join the Organization for European Economic Co-operation (OEEC) in 1948. The Soviet Union and its satellite countries were also offered aid but refused. Czechoslovakia, Poland and Hungary showed interest in the plan, but the USSR brought pressure on them not to participate and countered with its own economic program for Eastern Europe.

One secretive provision of the Marshall Plan was that 5 percent of these funds would be withheld and used by the Central Intelligence Agency (CIA) to fund Operation Rollback efforts. Funds would be paid in local currencies for unspecified purposes (such as embassy upkeep). Money flowed to rollback efforts.[17] Funds to support guerrilla and popular revolt uprisings

would then be utilized in the Baltic Republics, Poland, Albania and other Iron Curtain countries to destabilize and weaken Soviet occupation and Soviet puppet governments. Operation Rollback was to recruit refugees from war-torn Europe for training otherwise tough fighters to create those popular uprisings and roll back the Soviet advances of the Second World War. Four aims of the program would be psychological warfare; political warfare, such as underground resistance support and encouraging defection; economic warfare, including market manipulation, the black market and counterfeiting; and, finally, direct action implemented by guerrilla sabotage demolition.

An individual with Wisconsin ties involved in the latter type of direct action was George Georgiev (later Georgieff after moving to the United States).[18] Born in 1930 in the village of Dinevo, Bulgaria, George Georgiev grew up during the years of Second World War, witnessing the Bulgarian Communist coup in 1944 that was a precursor to decades of communist rule and Soviet influence. George, along with many other young men of his age, was involved with the opposition movement and refused to join the Communist Party. Because of these actions and beliefs, George was not allowed to attend college. After a friend reported his opposition activities to the local party leaders in April 1950, at the age of nineteen, George and another friend left their families and homes to escape Bulgaria and avoid being put in a labor camp, as his cousin and other friends had been. The friends walked for three days to Greece and crossed the border on foot. They were eventually picked up by Greek soldiers, processed as refugees, and eventually taken to a refugee camp near Athens.

George had lived in the refugee camp for a few months when representatives from the CIA came to the camp to recruit men to train for espionage work. Although George had been waiting for a transport to emigrate, he decided to stay and assist the CIA, since he hoped that it meant he would be able to return to his homeland of Bulgaria. In January 1951, George and about twenty other young men from the refugee camp were flown to Germany to begin their training at a resort villa in the Alps. They trained for three months, learning Morse code and transmitting messages as well physical self-defense.

After training, George and the rest of his group were sent back to Greece. They were based there for five years, during which time George crossed and re-crossed the border into Bulgaria to collect information about the Communist Party's activities. Groups of two or three men would cross the border and set up base for a few months. They hid in the mountains and

George Georgiev in Bulgaria. *Jill Fuller*.

George Georgiev in Greece. *Jill Fuller*.

Left: George Georgiev training in West Germany. *Jill Fuller*.

Below: George Georgiev in a group on a training mission. *Jill Fuller*.

made contact with locals, collecting information that they then coded and sent back to the base in Athens. It was dangerous work; one of George's friends was discovered by the militia and killed at the border.

In 1955, Greece and Bulgaria entered into a treaty, and the CIA was no longer allowed to operate in Greece. As such, the men were relieved of their duties. By this time, one of George's uncles was in Germany, so George was able to emigrate to join him. He lived in Germany for two years, working for the U.S. Army as a guard at military depots until he received his visa and a sponsorship to come to America in 1957. He landed in Richmond, Virginia, and soon joined some friends who had settled in Chicago, Illinois. There he worked as a welder and eventually a tool and die maker. In 1958, he married Ursula Mursewski, who had emigrated from East Germany. They raised two children and lived in northern Illinois until moving to Sparta, Wisconsin, in 2004. George lived there until his death on February 19, 2012.

A STEADFAST MILWAUKEE POLITICIAN CHIMES IN: CONGRESSMAN CHARLES KERSTEN

As a successful and popular general, Dwight Eisenhower ran for the presidential nomination on concept to roll back communism peacefully in 1952. With the Korean War in full swing and the hunt for communists at home well underway, the American population backed the former Second World War general for president by a large margin. Before the election in 1951, Milwaukee congressman Charles Kersten managed to add a provision to secure $100 million in military aid to support escapees or those living in Iron Curtain countries.[19] Kersten hailed from a district that included many immigrants from Iron Curtain countries, including a large number of Polish nationals. In 1946, he ran on the slogan "Put Kersten in Congress and Keep Communism Out!"[20] During a campaign visit with Eisenhower in 1952, Kersten decried the need for an American policy to support resistance to "Stalin's hold" on "captive nations."[21]

As Ike's term began in 1953, events would dictate the need to roll back communism in Eastern and Central Europe in an offensive manner. Involvement in Korean War was winding down, and Josef Stalin's death in 1953 changed the course of Soviet-U.S. relations. It was thought that the Soviets might offer an opening to peace talks after the death of their leader. Further eroding confidence and credibility and lowering morale,

Eisenhower stood by while Soviet tanks rolled into Poland and Hungary in 1956, crushing popular uprisings. Those behind the Iron Curtain and immigrants back home supported taking the fight to roll back communism. By 1960, ideas of rolling back communism had stopped. Anti-communist conservative warriors such as Joseph McCarthy and Charles Kersten would be out of power in the mid-1950s. In 1961, the Berlin Wall would be erected, and a new chapter of suffering would take hold behind the Iron Curtain as the Soviet-backed governments would continue bowing to Moscow's needs for decades thereafter.

CHAPTER 3

THE DAY UNDER COMMUNISM

MOSINEE ON MAY 1, 1950

Five communists approached Ralph Kronenwetter's home at 6:00 a.m. on May 1, 1950. As mayor of the town of Mosinee, population 1,400, Kronenwetter was to be placed under arrest. A short time later, another group of "Reds" arrested Police Chief Carl Gewiss. The chief was subsequently "shot."[22] Soon to follow were a reverend of the Methodist Church, Will Le Drew Bennett, and the editor and owner of the *Mosinee Times* newspaper, an American Legion member and former brigadier general named Francis Schweinler. Each was jailed. The newspaper was renamed the *Red Star* and printed in pink. Soviet communism was taking over the town of Mosinee by force. The concept would frighten most, but it was actually a stunt, a mock "Day Under Communism" in the heartland of Wisconsin.[23]

This Day Under Communism was undertaken with perfect timing. A few months earlier, Joseph McCarthy was said to have stated that there were fifty-seven communists at the State Department. Alger Hiss had been unmasked as a sympathizer. The United States was under assault. China had fallen to communists not a year before, in 1949—the same 1949 that saw the Soviet Union test its first atomic bomb; the Berlin Airlift was successfully drawing to a close in 1949 as well. The airlift was a victory in an otherwise uncertain world. Little did anyone realize that the North Koreans would attack South Korea later in the summer. It was not a coincidence that this mock Cold War takeover occurred on May 1. May Day is traditionally a workers' holiday that is celebrated widely throughout the world, especially in those places espousing communism and socialism. Modern-day origins of May Day are

celebrated as a commemoration of the Haymarket Affair in Chicago in 1886.[24] The Haymarket Affair involved a significant deportee named Emma Goldman on the USS *Buford* (dubbed the "Soviet Ark"), sent to Soviet Russia under J. Edgar Hoover's direction in 1920. Thirty years after the Soviet Ark departed New York to transport 249 communists, socialists and anarchists to the Soviet Union, a demonstration of a different kind would be held in the small heartland city of Mosinee, Wisconsin.

Organization for the event began in earnest in January 1950, when members of the American Legion undertook a plan to stage the dangers of a Soviet-style takeover of the town on May 1 of that year.[25] The American Legion at both the local and national levels went so far as to invite ex-communists Joseph Kornfeder and Benjamin Gitlow to provide credibility and details to enact life under communism. Kornfeder was tapped as "Chief Commissar" for the day and tasked with designing entry permits and ration coupons. Kornfeder was a native Slovakian who was trained in political warfare at Moscow's Lenin School. He would break with the party in 1934 and testify for the House Un-American Activities Committee in the U.S. Congress.[26]

Benjamin Gitlow was a brighter star and bigger catch for the Legion event. Gitlow claimed an honorary membership in the Moscow Soviet, becoming general secretary of the United States Communist Party. Both men would offer rousing speeches at the Day Under Communism. Their criticism of the United States and its system was said to be worthy of a Politburo gathering. The two former communists crowed that the takeover under the guise of communism was happening as predicted by Lenin and others in the Bolshevik order.

The townspeople generally went along with the stunt, although some had reservations of the event. According to the *Wisconsin State Journal* in a remembrance piece in 2014, Gaby Rheinschmidt was twenty-two years old when he led nuns from St. Paul's grade school to the stockade. With a pistol at his side, he later guarded the soup kitchen on Mosinee's Main Street to make sure that order was maintained in the United Soviet States of America. Earlier in the day, at Mosinee Paper Mills, company executives had been ordered from their building, marched across the bridges over Bull Falls and imprisoned along with the nefarious nuns and other community leaders. Checkpoints were set up at the bridges leading into Mosinee's downtown, the prices of food at Martin's Red Owl and the A&P were inflated and some of the books were removed from the library.[27]

The town was notified of the event weeks before, and the organizers made sure to bring in the press. Publicity of the event far exceeded expectations, with nearly one hundred reporters registering to cover the event. Reporters came far and wide and included prominent *Life* magazine, *Reader's Digest* and even the Soviet *TASS* newspaper. Meals of potato soup, bread and coffee were the only sustenance allowed for the day. The only unscripted event that took place was when actual communists decried the event and spread leaflets among the town beforehand on April 30. Red Square was created at the center of the city, ending in a celebratory bonfire that destroyed all the Soviet propaganda after the mock event.[28]

The event would be overshadowed by real tragedy several days later, when the mayor and the reverend died within days of the mock communist takeover. Mayor Kronenwetter, who used the platform as a means to declare himself a United States Congressional candidate for 1950, fell into a coma and died on May 6.[29] Then Methodist reverend Will Le Drew Bennett suffered a heart attack and died on May 7. The Day Under Communism, taken in the context of its time, was a response by patriotic citizens and veterans organizations in an uncertain time. To them and that generation, the Cold War was very real. Looking back, the Day Under Communism continues to spark intrigue and wonder as a unique moment in Cold War history that gathered much attention in 1950.

CHAPTER 4

JOSEPH McCARTHY

HERO OR PARIAH?

His name still invoked today to decry a "witch hunt," Joseph McCarthy made an indelible mark on American politics and society unlike any other senator of the twentieth century. Born to an Irish immigrant family in 1908, Joe McCarthy would represent the rough-and-tumble upbringing of a country farm boy in Grand Chute, Wisconsin, located in the Fox Valley near the city of Appleton. Most of his farm family eschewed traditional education, and Joe was no exception early on in his life. Instead, due to his family's need to make ends meet, Joe became a chicken farmer in his own right and sold eggs to local markets. It wasn't until age twenty-one that Joe enrolled in the local high school in Manawa, Wisconsin. He would earn a high school diploma within nine months and go on to attend Marquette University in Milwaukee.

After finishing law school and being admitted to the bar in 1935, McCarthy would start his run for political office—first as a district attorney in Shawano County in 1936 and then successfully as a circuit judge in 1939. Despite being exempt from war service as a judge, McCarthy enlisted in the United States Marine Corps in 1942. After accumulating a war record in the Pacific, he was deactivated in 1945 as the European war theater ended. He ran unsuccessfully for the United States Senate in 1944, but in 1946, McCarthy defeated Robert La Follette Jr. for that seat in the nation's capital. The farm boy from Wisconsin, an underdog who was as anti-establishment as could be, would find himself in a coterie of elegance in Washington. Upon seeing extravagant dress at a party, he quipped, "I wonder what these people would

Wisconsin senator Joseph McCarthy. *Library of Congress*.

think if they knew I raised chickens?"[30] Nonetheless, McCarthy would begin his Senate career as communism, a Red Scare and foreign policy dominated the country's consciousness. The Republican Party would have legislative power for the first time since 1930. Whether the establishment class would approve of Joseph McCarthy's origins, message, demeanor, presence or not, he would be a force to be reckoned with.

World events were primed for Joseph McCarthy's entrance in Washington, D.C. The Soviet Union had a stranglehold on Eastern Europe, where many immigrants in Wisconsin hailed from or had relatives or friends living. A plethora of Germans in Wisconsin undoubtedly took interest in the Berlin

Blockade and subsequent airlift, well underway during election season in 1948. Tales of "Uncle Wiggly Wings," Colonel Gail Halvorsen, brought attention and imagination to the episode. Colonel Halvorsen took initiative by sending chocolates, gum and candies to the children of that besieged city via parachute alongside the cargo drops of flour, coal, blankets and other foodstuffs to keep the citizens of the western sectors alive. In 1949, Americans and western countries cringed as the Soviet Union tested its first nuclear bomb. No longer did the United States have a monopoly on this super weapon that had caused the Japanese empire to surrender to the Allies in 1945, ending World War II. The year 1949 also bore witness to Mao Zedong and his Communist forces marching into Peking (now Beijing) and driving the Nationalist forces off the continent to the island of Formosa (now Taiwan). A Soviet agent embedded in the Manhattan Project during the Second World War would be partially responsible for the USSR gaining usage of an atomic bomb. Klaus Fuchs stayed on in other atomic science capacity projects until 1949, when he was unmasked. In early 1950, he would confess to being a Soviet spy.

The Red Scare was also well underway in 1948, as the House Un-American Activities Committee was ferreting out communists and fellow travelers deeply entrenched in the government. Richard Nixon, then a congressman from California, was awash in testimony from such figures as Alger Hiss and Whittaker Chambers linking the former's influence as a Soviet collaborator to the fall of China. In a precursor to McCarthy's own allegations and investigations, those accused of communism or communist sympathies would be surrounded by friends and professional acquaintances, including many who worked at the higher levels of government. Allegations would prove correct when the Venona Decrypts were finally declassified in 1995 proving that Hiss, like many others, such as Harry Dexter White and Harry Hopkins and other New Deal progressives, had indeed some connection to the KGB or Soviet espionage.

With the stage set for postwar suspicion, Joseph McCarthy provided a rousing speech in Wheeling, West Virginia, in 1950 claiming that there were communists working in the United States government. Arthur Hermann, in his book *Joseph McCarthy: Reexamining the Life and Legacy of America's Most Hated Senator*, stated that it's the most famous, and least read, speech in modern American history.[31] No record exists, and McCarthy denied uttering the phrase. Only the editorials of major newspapers, political rebukes and the chattering class kept the record of 205 names of government employees in the State Department.

McCarthy would continue his obsession and champion the cause of outing communists in the United States government. He would overstep his boundaries in public trust, however, when he would challenge former general and secretary of state George Marshall's loyalty, as well as the lax security of the United States Army at Fort Monmouth in New Jersey. In McCarthy's defense, evidence suggested that General Marshall was not vigilant in his dealings with communist China. The Army Signal Corps at Fort Monmouth had also been home to the infamous Julius Rosenberg, who had spied for the Soviet Union. Rosenberg also recruited his brother, David Greenglass, at Los Alamos, where Greenglass worked and passed along information to the Soviets for their atomic program. After Julius and Ethel Rosenberg were arrested, two scientists from Fort Monmouth, Joel Barr and Alfred Sarant, defected to the Soviet Union in 1950.[32]

Public confidence turned against McCarthy, however, when it was countercharged that he and his assistant, Roy Cohn, had stepped in to provide favorable treatment to fellow staff member David Schine, recently drafted into the United States Army. McCarthy would be acquitted, but the damage as seen on the televised hearings was done. On December 2, 1954, he would be censured by a vote of 65 to 22. Abstaining from that vote was family friend John F. Kennedy, who scheduled back surgery for that day. McCarthy would lose his chairmanship of the committee on government operations with the change of governance back to the Democrats in 1955 and fade into obscurity. McCarthy would die due to complications of alcoholism in 1957 and is buried in Appleton, Wisconsin.

CHAPTER 5

THE SKY IS FALLING

SPUTNIK IV CRASHES IN WISCONSIN

As the Cold War approached its second decade between the Soviet Union and the United States, the external atmosphere of space became an uncharted and challenged battleground between the two superpowers. Superiority of space, designs for human space travel and the prestige of the best system of government were at stake. More importantly to both sides of the Cold War were any military weaponry, communications systems and surveillance that could gain an upper edge in a perceived conflict of a third world war. Enter Sputnik, the first man-made satellite built by the Soviet Union; it become a scientific and military symbol that would change history and vault mankind into the world of space.

Sputnik, meaning "satellite" in Russian, was in sporting parlance a game changer, dealing a significant blow to the United States in the race to space. At the time of its launch in 1957, most Americans held a sense of confidence that the technological capabilities of their country were second to none. After all, America, with its newfound peacetime abundance and booming economy, was on the cutting edge and leading the world in inventions, spanning everything from transistor radios to a cure for polio. But when the Soviet Union launched Sputnik into space, it catapulted itself into the lead of the space race. The stakes were thus incomparably raised in the Cold War.

The space age reality of conquering that new frontier would materialize five years later in the small, unlikely city of Manitowoc, Wisconsin, on September 5, 1962. What remained of Sputnik IV reentered the atmosphere

with a blistering scream over the skies of Wisconsin in the wee hours and was tracked down to the shores of Lake Michigan by amateur scientists looking for pieces of the satellite burning up in the atmosphere.

ATMOSPHERE

Korabl-Sputnik 1 (more commonly known as Sputnik IV) was the fourth such launch of the Sputnik satellites on May 15, 1960. The launch occurred during a time when the political and military climate between the Soviet Union and United States could not be at a tenser level. May 15 was exactly two weeks after the downing of American U-2 pilot Francis Gary Powers over Sverdlovsk, USSR. Moreover, a summit between the two nations was to convene the following day after the launch of Sputnik IV on May 16, 1960, in Paris. The summit would feature an irate Nikita Khrushchev storming out of a meeting with President Dwight Eisenhower over the continued violations of his airspace by the U-2 overflights.

Francis Gary Powers's mission was to underscore the pressure the United States was under to gain critical information on the status of the Soviet program at Balkanur cosmodrome. In addition, knowledge of the intercontinental ballistic missile capabilities the Soviets were developing, harboring and aiming at the West was a priority. The U-2 piloted by Francis Gary Powers was to take off from Pakistan and end with an overflight of the Soviet Union, landing in Bodo, Norway, to gain photographic evidence of Soviet capabilities in those areas. Instead, the spy plane was shot down over the USSR by a SA-2 surface-to-air missile in Sverdlovsk.

To manage the situation, the United States issued a cover story through the National Aeronautics and Space Administration (NASA) that one of its weather research planes had veered off course and had experienced oxygen issues. Evidence of the U-2 spy plane was presented by Nikita Khrushchev; it was found largely intact, along with much of the plane's sensitive instrumentation and capabilities. Its pilot, Francis Gary Powers, was introduced to the world by Nikita Khrushchev alive and well, creating an embarrassment to President Eisenhower and his administration. Equally damaging was the revelation and acknowledgement of the Central Intelligence Agency (CIA) and the National Security Administration (NSA) to an American public not aware of such activities that their government was involved with such missions.

After the launch of Sputnik IV under such tense Cold War circumstances, ground personnel at Balkanur cosmodrome lost operational control of the Soviet satellite a month later, on June 15, 1960. Rockets assigned the task of bringing the satellite back to earth misfired and caused the spacecraft to ascend into a higher orbit. With a dummy astronaut on board, its payload was a harbinger of manned flight as a test of the effects of space on humans, as would be witnessed to an astonished world a short time later with Yuri Gagarin's orbiting of the earth in 1961. Sputnik IV contained "scientific instruments, a television system, and a self-sustaining biological cabin." It measured stress of human space flight and pre-recorded voice communications.[33] With the loss of control, the ability to further study human communications from space would have to wait.

SPUTNIK IV LANDS IN MANITOWOC, WISCONSIN

As with prior launches, dating back to the inaugural Sputnik in 1957, amateurs and professionals alike tracked the satellite trajectory of Sputnik IV. What remained of the satellite was scheduled to disintegrate in the atmosphere in 1962 when groups of "Moonwatchers," volunteers around the United States, narrowed possible landing sites on September 5, 6 or 7, 1962.[34] Calculations were keen to *when*, but the many watching the skies had no idea *where* the Soviet satellite would land.

Enter the story of Wisconsin's role in the Cold War Soviet space program. At about 5:30 a.m. on the morning of September 5, 1962, Manitowoc police officers Marvin Bauch and Ronald Rusboldt were on routine patrol when they noticed what appeared to be cardboard in the middle of Eighth Street, a main throughway of this town located along Lake Michigan.[35]

Thinking it was refuse, the officers initially ignored it. Making the rounds once again, while returning to the scene an hour later, the officers attempted to move the item since the object was a traffic hazard. When the officers realized that the object was hot to the touch, they associated this casting with a piece from the local foundry, promptly kicking the twenty-pound chunk of steaming metal to the curb. The metal fragment had made a three-inch-deep impression in the middle of Eighth Street.

With the Moonwatchers at the ready, news quickly spread that Sputnik IV had made reentry into the atmosphere somewhere over Wisconsin near

Officers Marvin Bauch and Ronald Rusboldt at Sputnik IV landing site in Manitowoc, Wisconsin. *Rahr-West Art Museum.*

the coast of Lake Michigan. Soon enough, Officers Bauch and Rusboldt made the connection that the piece of metal they had observed, dismissed and ultimately attempted to move out of the street was indeed the fourth-generation Soviet satellite that had launched on May 15, 1960.

A HISTORY OF THE SPUTNIK PROGRAM

The significance of the Sputnik program in the Soviet Union cannot be underestimated. The Soviet Union was aware that the United States Air Force had at its disposal long-range bombers that could fly nuclear payload from bases in England, West Germany, Turkey, South Korea, Japan and others into all corners of the Soviet Union. Premier Nikita Khrushchev was livid with the United States U-2 spy planes flying over the Soviet Union at nearly seventy thousand feet as well. The Soviet fighters sent scrambling to intercept the U-2 were no match for the lightning-fast American spy planes. The U-2 missions were a means to photograph and determine Soviet military installations, troop strength, shipyards, missile sites and atomic testing sites, and glean other significant information to keep an edge in the Cold War. When the Soviet rocket program under Sergei Korolev and other Soviet engineers took shape after the Second World War, Nikita Khrushchev found an apparent fascination with rockets and ballistic missiles. Nikita's son, Sergei Khrushchev, an engineer in his own right, would reminisce about a meeting with Korolev involving a world map marked with the distance missiles could travel into enemy territory. Great Britain and France could equally be destroyed and conquered with five to nine missiles.[36]

Sergei Khrushchev once told me that his father embraced a solution to altering not only the power of missile development but also the cost effectiveness of ballistic missiles to close the gap of American air and nuclear superiority. Due to overwhelming costs, and having fallen technologically behind the Americans, the Soviet Union could not develop a bomber program to match the United States. In its stead, Khrushchev would race to pull ahead in the development of intercontinental ballistic missiles (ICBMs). Rocket and spacecraft design to gain an edge in the superiority of space would become top objectives. As far as the Americans were concerned at the time, the United States was far advanced in air superiority and nuclear capabilities; the Soviet budget for satellites was merely $88,000 in 1954.[37] Sputnik's launch in 1957 would serve as a wake-up call.

An ancillary effect of ICBMs would close the many surface-to-air Nike missile sites around the United States, including those in Wisconsin. Nike missile sites were tasked with patrolling the skies for enemy Soviet bombers traveling over the polar regions en route to drop their nuclear payloads on United States targets. With the rise of ICBMs and the

underwhelming test performance of missile interceptors such as the Nike Zeus, the Nike sites were deemed costly and obsolete for future Cold War conflict and shut down as part of the Strategic Arms Limitation Talks (SALT) in 1970.

A PIVOTAL MOMENT OF SPUTNIK

Nikita Khrushchev's gamble on space paid off when history was made on October 4, 1957, as the Soviet Union successfully launched Sputnik. After several years in development, Sputnik was planned in accordance with the International Geophysical Year (IGY) from July 1, 1957, to December 31, 1958. This period of time was designed to foster more cooperation in the world's efforts to understand the sciences. Both the United States and Soviet Union pledged to launch satellites during the IGY. Not to be outdone, each side would use the occasion not only as a diplomatic show of goodwill but also to test its military capabilities.

The first Sputnik certainly did not warrant first prize in a beauty contest. The world's first successful artificial satellite launched into outer space could accurately be described as a 183-pound metal sphere the size of a basketball with attached radio antenna. To be fair, how it looked was not at the top of Sergei Korolev's concern, the man who would be plucked from a Siberian work camp in the Soviet gulag system in 1939 and go on to direct the Soviet rocket and satellite program. Korolev insisted that Sputnik be a sphere since, combined with polished aluminum material, the satellite would be seen in the upper recesses of the atmosphere.[38]

After being successfully launched on Vostok rockets, the Sputnik satellite sent a series of beeps through four radio antennae that could be tracked and heard with ease with the correct equipment. One needed only a short-wave or ham radio to track the satellite as it passed overhead transmitting signals. Sputnik did so for nearly three weeks before the batteries wore out. Sputnik continued in orbit until January 1958, when the satellite malfunctioned and burned up in the atmosphere.

Needless to say, the Sputnik launch ushered in not only a new era of scientific discovery, wonder and amazement but also a hitherto unforeseen fear of the Cold War consequences. Sputnik's presence in space caused alarm all over the United States and fostered a new approach to federalizing education, highlighting the need for science,

math and engineering in American school systems. After all, superiority in conquering the heavens had a direct implication on intercontinental ballistic missiles carrying nuclear payloads to the opposing forces of each country. The Sputnik satellite, although crude in design compared to technology today, covered nearly every habitable place on earth over the skies above during its orbit. Thus, there was no place to hide from the reach of the Soviet's technological edge and potential military reach. It was therefore necessary for the United States to put immediate resources into finding a way to get the upper hand in the Space Race. One significant reaction in the United States was the National Aeronautics and Space Act in 1958, which resulted in the creation of the National Aeronautics and Space Administration (NASA).

The U.S. Department of Defense watched with unease and concern, immediately responding to the ensuing political furor by approving funding for another U.S. satellite project to compete with the Vanguard satellite program. As a simultaneous alternative to Vanguard, Wernher von Braun and his Army Redstone Arsenal team began work on the Explorer project. Explorer I would launch successfully in January 1958. This successful launch allowed the United States to keep up in the Space Race and save face by launching a satellite as promised during the International Geophysical Year.

For its part, the United States had been working on the Vanguard satellite program for years. Like the Soviets, the United States vowed to launch a satellite into space during the International Geophysical year. The Vanguard weighed in considerably lighter than its Soviet counterpart at 3.5 pounds. After taking second place in a two-man race to space, with Sputnik entering the heavens first, insult led to injury as the Vanguard launch on December 6, 1957, was a complete disaster. The rocket fell back to the launch pad a mere two seconds after liftoff. The small Vanguard satellite flew off and was too damaged to recover or reuse. A black eye to the United States space program was met with glee by the Soviet Union in the space race. Some labeled the United States effort "Flopnik" and "Kaputnik." The naval Vanguard program would be scrapped, and Wernher von Braun would lead his scientific and engineering team of American and former German colleagues in the Explorer satellite program, which would launch in January 1958 to stymie momentum held by the Soviet space achievements.

Meanwhile, as the United States satellite efforts fell flat, the Soviets continued to march along their path to cementing space superiority. Sputnik II was launched barely one month later after the initial Sputnik

Laika the dog, Soviet space pioneer. *Library of Congress.*

on November 3, 1957. As with the United States' space goals, the Sputnik series of launches was built on the premise of sending humans into outer space. This particular Sputnik launch was memorable in that it involved a dog named Laika. Laika would become the first dog and animal to orbit Earth. She was preceded in the animal sequence of space visitors by fruit flies, mice, American monkeys and other Soviet dogs, all launched on prior missions above the atmosphere by both the Soviet Union and the United States. Within a few years of Laika's historical space visit, frogs and rabbits would also soon hitch rides into outer space. Sadly, the Soviets did not place an emphasis in having animals return safely, and Laika died of heat exhaustion after five hours in space. The Soviet Sputnik II mission achieved a scientific first when the first human to orbit the earth was launched from an advanced Vostok rocket a year later. Yuri Gagarin, Soviet cosmonaut, represented humanity's first orbital passenger on April 12, 1961. It further cemented the Soviet position as leading the charge into space.

FATE OF SPUTNIK IV

As the remnants of Sputnik IV fell to Earth, two industrial engineers from Milwaukee, Ed Halbach and his assistant, Gale Highsmith, had been tracking Sputnik IV on the morning of reentry. The duo oversaw a team of volunteers called Operation Moonwatch, a volunteer organization assisting the Smithsonian Astrophysical Observatory (SAO). Moonwatch teams were first at the ready during the initial Sputnik launch of 1957, earlier than most tracking stations were operational in the United States. According to their calculations, teams across the country had been prepared to observe the skies around the clock on September 5, 6 and 7.

It was reported that Highsmith found what he was looking for as Sputnik IV came into sight at exactly 4:49 a.m. on September 5, 1962. The satellite predictably splintered into several pieces, with sightings occurring about twenty miles from his home in Milwaukee. Fiery orange balls traced like streamers in the sky, and many early risers reported seeing the fragments as they lit up the morning darkness.

A short time after Manitowoc police officers Marvin Bauch and Ronald Rusboldt discovered the remains of Sputnik IV on routine patrol, the Soviet satellite was sent to the *Milwaukee Journal* for evaluation. It was concluded that this piece of Sputnik IV should be sent to SAO in Cambridge for further testing and confirmation of its origins. Because of his sighting, Gale Highsmith was asked to accompany the remains to Cambridge for examination to see if the piece of twenty-pound metal was indeed the satellite they were looking for. Further analysis was sought at Los Alamos Scientific Laboratory, Air Force Research laboratory in Cambridge and other agencies to corroborate the findings of the Smithsonian.

Upon exhaustive verification, the United States government offered it back to the Soviets. Coincidentally, the United Nations was debating the legalities of satellite remains falling back to Earth. On September 12, remains of Sputnik IV were delivered to the U.S. Mission to the United Nations. The Soviets refused, due to differences of opinion in the legalities debate in the United Nations. Four months later, however, on January 3, 1963, the Soviets accepted the remains of Sputnik IV. At that point, only fourteen pounds of the spacecraft remained after analysis.

According to the Rahr West Art Museum, the Manitowoc Common Council accepted two replicas of the Sputnik IV created by NASA in 1963. One replica of Sputnik IV can be seen at the Rahr West Art Museum. In November 1963, the spot of the Sputnik IV crash was permanently

Above: Sputnik historical marker. *Below*: Sputnik landing spot.

marked with a ring on Eighth Street in Manitowoc. An annual festival commemorating the landing of Sputnik IV, called Sputnikfest, generally takes place the first full weekend in September. The festival encourages attendees to dress in wacky alien attire.

CHAPTER 6

NUCLEAR MISSILES IN WISCONSIN

PROJECT NIKE

WELCOME TO THE ARMY

Army private Colin Sandell arrived on Waukesha's nuclear-equipped Nike Hercules missile base on October 19, 1962. The Waukesha Nike site was his first assignment out of the army's technical training school at Fort Ord in California. The Nike Hercules was a surface-to-air, anti-aircraft missile system tasked with shooting down incoming Soviet bombers over United States airspace. Since the polar regions were the shortest direct route to targets inside the United States, Soviet bombers would have journeyed over the Arctic in the event a third world war broke out. Three days later, on October 22, Colin would find himself being processed on his new base in the orderly room. As Colin was experiencing a brief welcome, commotion erupted as men scrambled to their radar stations as well as to the nearby missile pits. The missile base had received word that it was going into a "hot status," which meant that the Hercules nuclear missiles were ready to be fired within five minutes of an order. The base went to DEFCON 3 that day, increasing the threat of war.

At the same time that Colin was being processed into his first assignment in Waukesha, Wisconsin, the world was risking a deadly nuclear standoff. More than one thousand miles to the south, there was an incident brewing in Cuba. The Soviet Union was erecting missiles a mere ninety miles off the coast of Florida. With the assistance of Fidel Castro taking power in Cuba since 1959, and Castro's ability to work

Francis Gary Powers Jr. and Sergei Khrushchev at Waukesha Nike site in 2006. *Author's collection.*

closely with the Soviet Union, the United States was under threat of nuclear attack from the USSR.

At issue with the United States and its young leader, John F. Kennedy, was what to do about this precarious situation. The Cuban Missile Crisis was arguably the closest the superpowers ever came to exchanging nuclear attacks. Kennedy decided that the best way to combat the situation was to blockade the island nation of Cuba. United States U-2 reconnaissance planes and satellites closely monitored the island as well as the Soviet ships carrying the nuclear missile payloads. All branches of the United States armed forces were on alert, including U.S. Army bases watching the skies for incoming enemy bombers traveling over the polar regions of the United States. The situation defused, cooler heads prevailed and Nikita Khrushchev removed the Soviet missiles from Cuba. That incident would start the downfall of Khrushchev's leadership.

MILWAUKEE'S DEFENSE RING

After the Second World War, more than two hundred Nike missile sites sprang up all over the United States to become the next generation of anti-aircraft weapons to deter invasion by an enemy air force. The first-generation missile was the Nike Ajax, a conventional warhead that would soon be replaced with the Nike Hercules. The Nike Hercules missile was

Fire control area Waukesha Nike site, circa 1962. *Colin Sandell*.

Nuclear-equipped Nike Hercules at the Milwaukee lakefront, now the Summerfest Grounds. *Colin Sandell*.

Enlisted personnel at the Waukesha Nike Missile Site. *Colin Sandell*.

outfitted with a nuclear warhead, each with the strength of similar size and power to those dropped on Hiroshima and Nagasaki in Japan during the end of the Second World War.

WHY NUCLEAR MISSILES IN WISCONSIN?

Milwaukee was home to a large manufacturing base that would have undoubtedly become an industrial target in the event of a third world war breaking out between the Soviet Union and United States during the Cold War. Wisconsin companies like Allis Chalmers and International Harvester, buttressed by foundries and various factories, would have become targets

too. In addition, paper mills were present in northern Wisconsin and Green Bay areas, as well as Chrysler motor plant in Kenosha and General Motors production lines in Janesville. As such, the metropolitan Milwaukee area was outfitted with eight missile sites starting in 1956: Waukesha, Milwaukee, Menomonee Falls, Muskego, Cudahy, Franklin, Silver Spring and Hales Corners. The Milwaukee-area Nike missile bases were part of the larger Chicago-Gary, Indiana "Rings of Supersonic Steel." In all, the Milwaukee-Chicago-Gary ring totaled thirty-two missile sites to deter and protect against a Soviet bomber attack.

Nike Missile locations in the Milwaukee area included:

- M-02, Brown Deer Road, 1957–71
- M-20, Harbor Drive, 1957–71
- M-42, city of Cudahy, 1956–61
- M-54, city of Hales Corners, 1956–61
- M-64, city of Muskego, 1956–63
- M-74, city of Waukesha, 1956–71
- M-86, village of Lannon, 1956–58
- M-96, Silver Spring Drive, 1956–63

The eight original Nike Ajax missile batteries were reduced down to three sites once the Nike Hercules replaced the Nike Ajax. The nuclear missile sites were to become the Waukesha, Milwaukee (Summerfest grounds) and Brown Deer locations. A further four missile sites were located in the Minneapolis ring protecting that region from Soviet bomber attack:

- North: MS-90, located in East Bethel, Minnesota
- South: MS-40, located in Castle Rock, Minnesota
- East: MS-20, located in Roberts, Wisconsin
- West: MS-70, located in St. Bonifacius, Minnesota

The first-generation Nike Ajax missiles were conventional explosive warheads. The idea of these missiles was to come close to hitting approaching enemy Soviet bombers and damage the bombers before they inflicted damage on their targets. This meant destroying any portion of the aircraft as a means not necessarily in destruction but in taking the incoming aircraft off its trajectory and mission. In 1960, the next-generation Nike Hercules was beginning to phase out the conventional warheads and replace them with a nuclear warhead equivalent to those bombs dropped on Nagasaki

and Hiroshima. The nuclear warhead was chosen because of its ability to knock out several incoming Soviet long-range bombers.

The Nike missiles were a last line of defense for those Soviet bombers. The missile sites were under control of the North American Air Defense Command (NORAD). The overall defense plan was to engage Soviet incursions into Canada, where the population was more sparsely dispersed, to minimize casualties. The Distant Early Warning Line (DEW Line), Near Canada Line, followed by the Nike Missile sites, would take their places as the last-ditch attempt to take out any remaining bombers. For the Milwaukee-area missiles, the radar would have picked up incoming bombers over northern Wisconsin and aimed and tracked toward those underpopulated areas. Colin Sandell remarked that they might have barely launched two or three missiles, if they were lucky, before being taken out by Soviet aircraft. Several Nike veterans also noted that there was nowhere to hide from the nuclear fallout that would have ensued after detonation in the skies over Wisconsin. If the bombers reached this far, they surmised, devastation was the only recourse.

NIMBY ("NOT IN MY BACKYARD") DID NOT APPLY

Residents in Waukesha, including those living in proximity of the fire control area at what is now Hillcrest Park, were said to be very supportive of the military base and its mission. The 1950s were a time of recognition that the Red Menace was real and an inherent danger to the United States. According to Nike veterans of the Waukesha site, there was never any official mention that the sites contained nuclear-equipped missiles until 1975, a full five years after the United States Army closed the Waukesha Nike site. There were rumors around town that the missiles had nuclear capabilities, however. In reality, at any given time during their presence, twelve nuclear warheads were ready to be placed on top of the delivery systems. Having that kind of firepower on standby in case of war is humbling.

One resident who lived next to the launch area on the corner of the now Les Paul Parkway and Cleveland Avenue in Waukesha recalled seeing missiles erected in launch position and not thinking much about it. Virginia Tapper, then widow of the Amron Corporation founder Kenneth Tapper, was dumbfounded as to what might be happening to erect a missile in the launch position. She quipped that she couldn't do anything about it anyway.

Colin Sandell added that many of the residential units were present during the base's existence. Much of the community was supportive of the fight against the Soviet Union and united in its purpose to defeat the Red Menace. There was no overwhelming effort to remove the army base from its location at what is now Hillcrest Park in Waukesha.

BAPTISM BY FIRE

Colin Sandell was a trained radar technician and expected to fulfill that role during his time on base that weekend in October. Instead of reporting for his technical discipline, he found himself guarding a young lieutenant burning important documents in case of a Soviet invasion. Colin was to guard the lieutenant while he was destroying classified operations found in the lieutenant's safe and was instructed to shoot to kill anyone interfering with the operation. During the next several tense days of the Cuban Missile Crisis, the men on the Waukesha Nike Missile site slept with their carbines, fully clothed and carrying gas masks. They were prepared for attack and thought they were going to die.

Some twenty miles away, Terry Klimek recalled a different scenario at the Muskego site. Men were instructed to bring weapons from home for an anticipated invasion. Klimek was a Wisconsin Army National Guard member on the Muskego base. He also indicated that there was an enemy list on hand that included suspected subversives in the area. The suspects were surveilled just in case war broke out.

The land occupying the Waukesha Nike Missile site was once very different in appearance. When the United States Army inspected the area in 1955 as a possible location for a missile base, the area was covered with sprawling farmland. The army went so far as to keep the drilling of holes and taking soil samples secret so as not to elevate the property values of land it was testing for a military base. Dr. Paul Rempe, a history professor of mine at Carroll University in the 1990s, shared stories of his family's farm that would become part of the base. The army had asked several farmers to make concessions on the land to locate the base near or on their properties. Rempe mentioned that his father, a decorated German World War I pilot during the First World War, accepted the offer to abut and overtake the edges of their family farm in Waukesha. Upon his acceptance, as Rempe recalled, the other farmers let it be known—in no uncertain terms—that the farmers

were being undersold on price by the government. The offer was rescinded, and a more favorable agreement was reached among all the farmers.

The Nike sites in each city underwent a familiar design. Two parcels of land in each city, noted for their highest points in that locale, were selected for locations of fire control and launch areas. The highest points were selected so as to not interfere with radar tracking. The fire control area served as a base for not only the radar towers but also the site where the men lived. The typical base had a barracks, a mess hall, an officer's club, a chapel and recreation facilities. The Waukesha site also had a basketball court and a hobby shop. The launch area, where the missiles were housed, was about two miles away as the crow flies. Missile were stored in pits, as opposed to missile silos that housed and launched intercontinental ballistic missiles. The missiles were readied for launch through an elevator and rail system that ferried missiles around the launch area. As with most military occupations, only those with clearance at the launch site traveled and worked at that portion of the Nike missile base. Those men residing on base would still live alongside their fire control counterparts, as well as those serving as barbers, military police, cooks and others who were there in a service capacity.

Waukesha launch area, 1959. *Colin Sandell.*

Right: Entrance to missile pits in former Muskego launch area. *Colin Sandell*.

Below: Underground in Muskego missile pits. *Colin Sandell*.

Nike Hercules launch at White Sands missile range, 1962. *Colin Sandell.*

It is estimated that about four to five hundred men served at the Waukesha Nike Missile site at its height during the United States command from 1956 to 1964. From 1964 until 1970, the Wisconsin National Guard took command of the Waukesha Nike Missile site until the base was shut down. For two weeks out of every year, the men would travel to White Sands Proving Grounds

Test Range in New Mexico to demonstrate their aptitude on the missile systems. The White Sands Proving Ground was where Wernher von Braun and other scientists of Hitler's Nazi war machine were placed in secrecy in 1945. Operation Paperclip scoured Germany for potential scientists of use to the United States after the Second World War ended.

It was at White Sands that both of Terry Klimek's Muskego and Waukesha units received commendations for their mastery and testing phase. Terry, along with Colin Sandell, was also routinely part of testing done over the Nike missile sites by American bombers. Strategic Air Command (SAC) bombers, in particular B-58 Hustlers and B-52 Stratofortress Bombers, would fly over the sites to test radar response times and their ability to acquire and hold bomber targets for the missiles systems. According to Terry's estimation, radar ground equipment had a difficult time locking on to the SAC training bombers and holding them for a desirable amount of time. At least three times during the Cold War, bombers flying over Wisconsin would end in tragedy with crashes. Two occurred in Wisconsin, and one was just over the border near Minneapolis.

During the active duty phase with the army, men came from all over the United States to serve at the base. Several people familiar with the Nike site recalled feeling sorry for southerners stationed at the base who had to experience their first taste of cold Wisconsin winters. Several men stationed at the base married local women and stayed on to work, live and raise their families in the Milwaukee area.

FATE OF THE NIKE MISSILES

The Nike missile sites around the country had been largely shut down by 1971 under terms of the Strategic Arms Limitation Talks. Sergei Khrushchev noted that his father, Nikita, was putting more emphasis on long-range intercontinental ballistic missiles (ICBMs). With the new threat and focus of these ICBMs by both sides, the Nike missile sites were rendered ineffective against that type of warfare weapon. A Nike Zeus missile was in development for years as a solution and deterrent to the ICBMs. But the Zeus was never fully deployed, falling out of favor for the Patriot missile in later years. Also factoring into the Nike missile's demise, the Vietnam War was taking up more manpower and resources; shutting down the Nike systems was an efficient decision compared to closing the bases outright.

The fate of the Nike missile sites varied by community. The sites were granted back to these various communities for development of park and recreational purposes through the federal Department of the Interior via the National Parks Service. Through its initial phase, Secretary of Defense Donald Rumsfeld, who served under Presidents Richard Nixon and George W. Bush, signed the deed that resulted in the City of Waukesha receiving title to both parcels of land in Waukesha. The Milwaukee lakefront missile site became part of the famous Summerfest grounds, where hundreds of thousands of visitors listen to multiple genres of music and attend cultural festivals every summer in June, July and August. Undoubtedly, few people would be aware that nuclear missiles once pointed to the skies for incoming Soviet nuclear bombers with the sole purpose of annihilating the area.

As of this writing, the Waukesha Nike Missile site continues to be Hillcrest Park at the former fire control area. The launch area is an undeveloped tract of land that was transferred back to the City of Waukesha after cleanup by the U.S. Army Corps of Engineers in the early 2000s. Other tracts of land for former Nike missile sites found their way into private hands, creating businesses, industrial usage and subdivisions. Most of the buildings and towers that once stood for decades, awaiting a Soviet bomber attack and housing men and equipment on base, have largely been bulldozed and obliterated. Remnants of some Nike base buildings have been used for storage at county parks, such as Menomonee Falls. Thankfully, these Nike missiles in Wisconsin were never deployed for war—even though they came close during the Cuban Missile Crisis in 1962 and were on heightened alert during the JFK assassination in 1963. The Nike missile era is worth remembering and preserving as a local

Entrance to Hillcrest Park, formerly IFC area of Waukesha Nike site. *Colin Sandell.*

Colin Sandell at the historical marker, IFC area. *Colin Sandell.*

HIPAR and TTR radar tracking systems, Waukesha IFC. *Colin Sandell.*

historical legacy central to the Cold War in Wisconsin. With the help of many Nike veterans over the years, the Cold War Museum Midwest Chapter has been able to ensure that many people, young and old, learn about the historic impact these Nike missile sites had on the community. Heartfelt thanks to Colin Sandell, Terry Klimek, Sidney Miller and others who have led many tours of the Nike Missile Radar Site at Hillcrest Park. These men have given their time and effort to keep the memories of their service time and the base's importance alive for future generations.

CHAPTER 7
COLD WAR CASUALTIES

BOMBERS CRASH WHILE TRAINING OVER WISCONSIN AIRSPACE

BOMBERS CRASH TRAINING OVER WISCONSIN AIRSPACE

Several bomber flights over Wisconsin during the Cold War turned deadly. Training missions over Wisconsin airspace demonstrated the dangers and hazards of keeping United States bombing crews trained for 'round-the-clock missions should war with the Soviet Union ever break out. These missions included testing Nike radar sites for their capability of tracking bombers over Wisconsin airspace. Missions also encompassed simulating bombing runs, refueling capabilities, nighttime flights and evading enemy radar. Described here are three missions that had fatal consequences.

B-52 STRATOFORTRESS CRASH IN STONE LAKE, WISCONSIN, 1966

On November 18, 1966, a United States Air Force B-52 Stratofortress crashed near Stone Lake, Wisconsin. The flight had originated from Barksdale Air Force base in Louisiana. The crew was on a low-level terrain avoidance night mission. The bomber had just entered a low level and was calibrating the terrain avoidance radar when the crew got too low, clipped the tops of the

T.O. 1B-52G-1

Special Weapons & ASM Lock Indicator Panel

Figure 4-68.

released from the corresponding single carriage rack. Each light is supplied TR power through the bomb indicator lights switch and a bomb release indicator switch located on the corresponding bomb rack.

Rack Locked Indicators

Rack locked indicators (figure 4-68) are located on the special weapons and ASM lock indicator panel at the radar navigator's station. Each indicator has three indicating positions: LOCK, UNLOCK, and slanting stripe markings. Each indicator will register LOCK when the corresponding rack is locked and UNLOCK when the corresponding rack is unlocked provided the bomb indicator lights switch is in ON position. The indicators will register slanting stripe markings when deenergized. The UL OR AFT and UR OR FWD rack locked and rack unlocked indicators are also used with the SUU-24/A dispenser installed. Each indicator will register LOCK when the SUU-24/A dispenser fail-safe system is in the locked position, and UNLOCK when the fail-safe system is in the unlocked position. The indicators receive left TR power through the "Ind Lights Wpn Rel" circuit breaker on the aft BNS circuit breaker panel on the navigator's overhead panel.

Parachute Static-Line-Retain Lights

Amber forward and aft parachute-static-line-retain lights (5, figure 4-67) are located on the special weapons control panel at the radar navigator's station. When illuminated, the lights indicate the corresponding special weapon parachute static line will be retained when the bomb is released. The lights are not used with bombs carried in the multiple carriage racks. Each light is supplied TR power through the bomb indicator lights switch and a position indicator switch on the corresponding parachute static line control mechanism.

SUU-24/A Dispenser Reset Indicator Lights

Two SUU-24/A dispenser amber reset indicator lights (2A and 7A, figure 4-65) located on the bomb indicator lights panel, when illuminated, indicate that the pulse distributor relay has been reset to the first cell. One indicator light is provided for each dispenser. Upon releasing the first cell from either the forward or aft dispenser, the applicable reset indicator light will go out.

Store Jettisoned Lights

An amber store jettisoned light is located on the pilots' instrument panel (45, figure 1-14; 44, figure 1-15; and 5, figure 1-16) and a red store jettisoned light is located on the jettison control panel (10, figure 4-66) at the radar navigator's station. The light on the pilots' instrument panel is marked "Store Jettisoned" and the light on the jettison control panel is marked "Released." Both lights illuminate while a jettison circuit is energized. The jettison circuits are bomb bay bombs or ADM-20 launch gear), No. 1 external missile, and No. 2 external missile. The lights are supplied aft battery power through two circuit breakers marked "Jettison Contr" and "Jettison Pwr" on the right forward BNS circuit breaker panel.

Above and opposite: B-52 schematics. *John Van Altena.*

forest trees and crashed.[39] As of 1970, the markings in the forest were still visible on aerial maps of the area.[40]

Former East German Stasi prisoner John Van Altena (see chapter 10) and his family were eyewitnesses to the crash. The American B-52 stratofortress bomber was making a training run over his family's farm in Stone Lake, Wisconsin, in 1966. Slightly more than a year after John was released from

Figure 1-28 (Sheet 2 of 2). Hydraulic Power Supply Systems

Hoenchenhousen prison in East Germany, he and his family were on a hunting trip at the farmhouse. Everyone was stunned after both hearing and seeing an explosion just a few short miles away. John and his family joked that their gas-heated stove was ripe for exploding after witnessing their father attempting to light it on several occasions. In the shocking moments following this explosion, it was feared to be a nuclear bomb, given the era

and the vividness of the fireball. After investigating the scene for survivors, John and his family scoured the area before being interrogated by the United States Air Force. It was learned that nine airmen lost their lives in the explosion.

These Cold War casualties included:

- Major James Henry Crook, instructor navigator
- Captain Curtis E. Robertson, pilot
- Lieutenant Colonel Jack Atherton, instructor pilot
- Captains Edward E. Kamph, radar navigator, and Michael J. Dunlap, electronic warfare officer
- Lieutenants Darrick R. Negron, copilot, and Jerome P. Callegari Jr., navigator
- Master Sergeant Lonnie B. Woodard, electronics engineer
- Airman First Class Gerald D. Turney, gunner

B-47 STRATOJET CRASH IN HURLEY, WISCONSIN, 1961

In February and May 1961, two 40th Bomb Plot Bomb Wing B-47s crashed while on runs against the Ironwood Bomb Plot. The crashes occurred within two miles of each other in the forest, about fourteen miles south of Hurley, Wisconsin. Six crew members lost their lives. On February 24, Captain J.P. Garrett, Lieutenant T.M. Stalmach, Lieutenant G.H. Hanify and Lieutenant C.F. Weise were all killed when their aircraft went in. Later, on May 2, Lieutenant D. Hariton and Captain D.B. Rasmussen lost their lives, while Captains F. Mead and John Hill survived. In 2004, an individual built a small memorial on the site of the second crash. In 2012, members of the local NCO Association undertook a project to refurbish the memorial. Sergeant Curt Meyers (Ret.) of the U.S. Army headed this project, and in a short time, the group raised more than $20,000 for the memorial.

On June 28, 2014, the site was dedicated with a community-wide celebration and the presence of Captain Rasmussen's entire family. The citizens of the town of Hurley demonstrated their patriotism and deep appreciation for the sacrifices of Cold War warriors such as those who flew and maintained the B-47. The site was officially designated as a Wisconsin State Memorial and is open to the public.[41]

B-52 CRASH IN INVER GROVE HEIGHTS, 1958[42]

It was a warm, dark September evening in 1958. August Kahl and his fifteen-year-old son, Loren, were loading tomatoes onto their farm truck so they could get an early start to market in South St. Paul the next morning.

The sound of a jet bomber high overhead was nothing new to the Kahls. They had heard the sound before. There were the new jet airliners landing at Wold-Chamberlain, fifteen miles away, and there were the air force bombers on training missions that could be heard ever so often. But tonight, the sound seemed unusual. Loren Kahl followed the path of the sound as it circled around him, getting louder and louder. All at once, there was a heavy "boom" from an area on the other side of the barn. For an instant, the farm light blinked out, and then the Kahls were enveloped in a fireball that swirled around both sides of the barn. They began to run toward the farmhouse one hundred yards away, but the fireball seemed to surround them. The ground was on fire, and a noisy wind was blasting at their unprotected skin. Loren could feel the skin on his face tighten from the heat, August tripped on something, fell headlong into the roaring ground fire, regained his footing and found his way to the house.

Inside the house, six other members of August's family were struggling to understand what had happened. The house was an inferno. Part of the stairway had been carried away, and Grandpa Kahl needed help to get to the bottom. They managed their way out of the house and staggered some distance away from the heat to look back and catch their breath, most of them in shock and aghast at the scene.

Only scant minutes before, the cause of the massive explosion and fire, an Air Force B-52D Stratofortress, had been maneuvering at 36,400 feet overhead. On a Cold War training mission to simulate a nuclear strike on the Twin Cities, the plane had been carrying six flight crewmembers and two instructors. The plane from the 69th Bomb Squadron, 42nd Bomb Wing of SAC, had departed Loring Air Force Base, Limestone, Maine, earlier in the day. It had made ECM runs at Bath, Maine; Albany, New York; Williamsport, Pennsylvania; and Youngstown and Bellefontaine, Ohio. The flight had continued to Richmond, Indiana, where a GPI Nav-bomb run was started that was to terminate at Minneapolis. There it would be scored for accuracy from the Air Force Radar Bombing site at Wold-Chamberlain.

Four times the big plane crossed the target with "bombs away" for the fourth run at 2016 CST Minneapolis. As it rolled off the last run, something went wrong. An elevator trim "excursion" began to send tremors through

the ship. Whatever happened will never be known, for at this point the tail broke off the airplane, and it began a high-speed plunge straight for the ground. There was no remark from the crew, and no cockpit voice recorder or black box to record the last moments. From 36,400 feet, the ship dove toward earth, and in no more than 10.8 seconds, it had fallen 8,000 feet. Moments later, control tower personnel at Wold-Chamberlain witnessed an explosion in the direction of Inver Grove Heights. The plane's main structure had impacted on the August Kahl farm a few miles south of South St. Paul Airport.

Although the crew had remained silent, they had nevertheless taken action. Four crew members had ejection seats and fired themselves out into the night almost immediately. The other four crew, including the two instructors, had no ejection seats. It was for them to find an open hatch and leap to safety. Perhaps the centrifugal force kept them pinned to their crew positions, for they were unable to exit and rode the plane to the ground, being consumed in the explosion and fire.

Of the four who ejected and were subjected to a six-hundred-mile-per-hour jet stream from outside the ship, flailing arms and legs and contact with the aircraft structure produced fatal injuries to three. They were found long after searchers and investigators had arrived, still strapped in their useless seats, their parachutes ripped to shreds by air blasts. The copilot was the singular survivor. He had landed in a tree on a farm adjoining the Kahl property. Neighbors helped him walk to a waiting ambulance sometime after the crash.

Aerial photos taken the morning after the crash showed that the plane had come in at a flat angle, clipping off the top of a billboard alongside State Highway 52, just fifty yards from the impact spot. Five craters marked the positions the fuselage and each pod of two engines. One of the engines had bulleted through the Kahl farmhouse, smashing off the lower staircase. Pieces large and small littered the entire farm and were spread across neighboring farms. The tail of the aircraft was found three miles to the west.

Although the event was traumatic and carried front-page news in local newspapers for the next two days, apart from convincing local citizens that the plane was not carrying nuclear weapons, the accident was soon hushed up. Recoverable pieces of the aircraft were taken to the big Air Force Reserve Hangar at Wold-Chamberlain, where they were laid out for the Air Force Accident Investigation team. No further news was given to the public. As a result of the investigation, numerous changes were adopted in both the ejection procedure and in the design of the ejection seats themselves.

For the Kahl family, with August and Loren badly burned and the other family members burned and traumatized, they were able to recover enough compensation to pay for their hospitalization and build a new farmhouse on a different spot of ground than where the former house had stood. In the fall of 1995, when the Kahl farm was purchased by the City of Inver Grove Heights, these buildings were burned.

The accident happened on September 16, 1958. Thirty-eight years later, on September 14, 1996, a stone memorial was dedicated on the spot where the bomber had crashed. Under the sponsorship of the Minnesota Aviation Hall of Fame, all the major aviation museums in the Twin City area lent their support, both financially and physically, to at long last provide a marker to honor these Cold War veterans who gave their lives for their country. Today, the stone, with a finely etched tablet, reminds all passersby of the sacrifice of these men. The location of the memorial is at the intersection of Broderick Boulevard and Brooks Boulevard near the Inver Hills Community College, alongside Highway 52 in Inver Grove Heights.

CHAPTER 8

A SOVIET PRINCESS TAKES REFUGE IN WISCONSIN

SVETLANA STALIN ALLILUYEVA

Milwaukeean George Kennan's impact on the Cold War would go beyond the Long Telegram, Containment Policy and advocating for a Volunteer Freedom Corps. Kennan would also use his persona to help settle and comfort the most significant Soviet defector during the Cold War. In 1967, Kennan would befriend Soviet dictator Josef Stalin's very own daughter, Svetlana Alliluyeva, who eventually became a United States citizen in 1978.[43] Her defection and ultimate U.S. citizenship would create a stir within the Kremlin and serve as a public relations coup on behalf of the United States. In the most unlikely of scenarios, Svetlana would eventually find herself living anonymously in the rural Wisconsin countryside, unknown to most of her small community as well as the world at large.

Her knowledge of the United States had started much earlier, in 1943. During the Second World War, in 1943, Svetlana graduated from Model School no. 25 and wanted to become a writer. Upon learning this, Josef Stalin did not approve, instead insisting that she enroll in history at Moscow University.[44] At a time when the United States was an ally during the Second World War, Svetlana learned much about the United States in terms of history, economics and geography.[45] Born Svetlana Stalin in 1926, she entered the American embassy in New Delhi, India, on March 6, 1967. She was granted travel to India to ceremonially scatter her late husband Brajesh

Svetlana Stalin arrives in the United States, 1967.

Singh's ashes. After spending three months in India, she had decided to seek political asylum at the United States embassy in New Delhi.

Upon entering the embassy, the officer in charge of defectors was suspicious of this woman, Svetlana Alliluyeva. Not wanting the continued attention of the Stalin name, Svetlana had taken her mother's maiden name in 1957; Alliluyeva appeared on her passport.[46] As such, the name added to difficulties of properly identifying her as Josef Stalin's daughter.

LIFE IN THE SOVIET UNION

Svetlana viewed her relationship with her father as complex, wanting to believe in the Josef Stalin that was her loving father but seeing through his dictatorship persona as the man he became. Growing up Stalin's daughter had its privileges. As a little girl, Svetlana oftentimes would send small notes dictating to her father to take her to the theater or order her breakfast. Stalin would comply with a written affirmative, playing along with her wishes as if she were in charge. She was a model communist, attended good schools and enjoyed vacations to her father's dacha and other locations.

During the Second World War, she became aware of the brutality her father exercised on the Soviet population. Having grown into a young woman

at the age of sixteen, Svetlana experienced the shock of the complexities that existed between her and her father. She first realized his power when she fell in love for the first time. He forbade her from marrying Alexi Kapler, famed Jewish filmmaker of the October Revolution. Kapler was banished to the Arctic Circle in 1943 on a five-year prison sentence. Upon his release, Kapler returned to Moscow despite being warned not to. When caught by plainclothes police in 1948, Kapler was arrested and spent another five years back in the Gulag prisons of Siberia. Later in her life, Svetlana reflected that Kapler was the man she truly loved.[47]

Despite the USSR being one of the first countries to recognize Israel in 1948, Josef Stalin would continue his paranoia and distrust of Soviet Jews. The Doctors Plot would inflame the hysteria of Jewish meddling in communist affairs in 1952 and last through the death of Stalin the following year. Many doctors, including Stalin's own, were arrested and disappeared. After the Second World War ended, Svetlana's extended Alliluyeva family would be arrested one by one, charged with otherwise sensational and petty crimes and sent to prisons across the Soviet Union.

PATH TO WISCONSIN

During Svetlana's stay in Princeton in New Jersey with George Kennan and his family, Kennan would assist her in publishing *Twenty Letters to a Friend*, which described her family's tragic history through a series of letters to the physicist Fyodor Volkenstein. The publication, along with others, would provide her with money.[48] After staying in Princeton, in proximity to George Kennan, she turned down the opportunity to teach at the university in political history. Having caused quite a stir upon her arrival, Svetlana received many letters after settling in the United States. One persistent woman who contacted her was Olgivanna Lloyd Wright, widower of famed architect Frank Lloyd Wright. Olgivanna invited Svetlana to visit her Taliesin Fellowship community in Arizona in 1970. The original Taliesin community was started in Spring Green, Wisconsin, in 1911 and rebuilt in 1932 after a tragic fire. Olgivanna Wright took over the estate in 1959 and sought benefactors to contribute to the community. Not unnoticed was that Olgivanna had a daughter named Svetlana Hinzenberg, who passed away in a car accident in Wisconsin in 1946, along with her young son, Daniel. Svetlana Hinzenberg was married to architect Wesley Peters, an apprentice

of Frank Lloyd Wright. Peters had fallen in love with Olgivanna's daughter and married in 1935, when she turned eighteen.

Svetlana Alliluyeva accepted the invitation to visit in April 1970, and as the story has it, Olgivanna arranged the entire episode to have Svetlana Alliluyeva marry Wesley Peters. The plan played out to perfection: three weeks later, the couple was married without announcement. It was a tumultuous marriage due to the short courtship and the overbearing Olgivanna, who played more of a conniving spiritual and dictatorial leader for the Taliesin compound than a businesswoman. Svetlana moved back and forth to Spring Green in Wisconsin and the Taliesin compound in Arizona with her husband, as the architects did annually. Nearly one year into her marriage, Svetlana gave birth to a daughter named Olga in 1971. Olga was her third child, after leaving two grown children in the Soviet Union upon her defection to the United States. In 1972, the marriage was in free-fall due to the strictness of life under Olgivanna and monetary problems with Wes. The marital strife caused Svetlana to purchase a home near Spring Green with her daughter. The divorce took more than a year to finalize.

After years of taking up refuge around the United States, in England and a short stint back in the Soviet Union, Svetlana made her way back to Spring Green in 2002. In 2005, I had read rumors of Svetlana Stalin and her whereabouts. Internet chat rooms and websites suggested several theories. Speculation abounded that Svetlana had taken refuge in an unknown monastery or fled to Switzerland. I traced her whereabouts to Spring Green and found a listing for Lana Peters, which was said to be her married name. No answer the first time calling, but the second time a woman answered. After I asked for Svetlana Stalin, the woman indicated I had the wrong number. In 2007, Svetlana Stalin, aka Lana Peters, gave an interview for an upcoming documentary called *Svetlana*. Thereafter, she continued to live in relative obscurity, save for staying in contact with lifelong friends and a few interviews. She died in 2011 in an old age home in Richland Center at the age of eighty-five.[49]

CHAPTER 9

USS *PUEBLO*

A SMALL KEWAUNEE SHIP IMPOUNDED IN NORTH KOREA

The year 1968 was a watershed one for disruption in the United States and around the world. The Tet Offensive was launched by the North Vietnamese in late January. The offensive was a military victory by the United States forces but a PR disaster back home. Martin Luther King Jr. was assassinated in April. Bobby Kennedy would follow suit in June while running for the Democratic Party nomination. The Democratic Convention itself was in turmoil in Chicago, witnessing angry riots and fights on the convention floor. Riots and marches protesting the Vietnam War were consuming Washington, D.C., and cities around the United States. Later that summer, in Czechoslovakia, the Prague Spring would be crushed by Soviet forces.

On January 21, two days before the USS *Pueblo* was seized by North Korea, the Presidential Blue House, home to South Korean president Park Chunghee, was invaded by North Korean commandos.[50] Park survived the attack, but pressure ratcheted up between those two countries. War continued to loom on the Korean peninsula, and the Johnson administration went to great lengths to avoid another war alongside the one taking place in Vietnam.

The seizure of the USS *Pueblo* was no exception to the varied events of 1968. The *Pueblo* was captured off the coast of North Korea in international waters on January 20, 1968. Today, the *Pueblo* stands alone as the sole United States Navy registered commissioned vessel in enemy hands. The ship continues to be displayed as a museum in the city of Pyongyang, North Korea, at the Victorious Fatherland Liberation War Museum. I visited the

USS *Pueblo* before its journey to North Korea. *Library of Congress.*

Pueblo at the Victorious Fatherland Liberation War Museum in April 2015 during a visit while competing in the Pyongyang Marathon (see the epilogue for further details).

 The *Pueblo* serves as a constant reminder for North Korean visitors of the museum of the inherent danger of the United States. It also serves as a means to project the strength of the North Korean military might and the reputation of the Kim regime, to show that it is powerful enough to go toe to toe with the United States. During my visit to the museum, while standing on the *Pueblo*, the North Korean tour guide expressed how humanely the crew was treated during their imprisonment. She explained that the crew was well fed, kept warm and received daily exercise during their incarceration. The United States, she posited, was reluctant to free the crew members and resolve the situation. In other words, the North Koreans believed that the United States was to blame for the crew's eleven-month stay. Of course, the *Pueblo* crew would go on record saying otherwise. Most every prisoner lost an extraordinary amount of weight, putting their health in danger. The

prisoners ate what amounted to slop with flies in it. They were allowed a short time to exercise early in the morning in the cold, along with daily indoctrination of the virtues of socialism.

ORIGINS IN A KEWAUNEE SHIPYARD

The USS *Pueblo* (AGER-2) was originally christened U.S. Army vessel *FP-344*, classified as an 850-ton general purpose supply vessel built at Kewaunee, Wisconsin. It was the sixty-sixth ship launched from the Kewaunee Shipyards. A little while later, the ship was reclassified by the army as *FS-344*. Along with its sister ship, *FP-345*, it was built by the Kewaunee Shipbuilding & Engineering Corporation in Kewaunee. Both were Camano-class small cargo ships. Essentially, the two were identical twins. During the Second World War, both ships served in the South Pacific Theater in the Philippines. After the war, *FS-344* was moored for mothballing at the coal docks of San Francisco, California.

Laid up in 1954, the *FP-344* remained in reserve until 1966. The ship was transferred to the United States Navy in April 1966 and renamed the USS *Pueblo*. The *Pueblo* would be transformed into an 850-ton environmental research ship. Initially designated a light cargo ship (*AKL-44*), it soon began conversion by the LTV Corporation at the Puget Sound Naval Shipyard in Bremerton, Washington, to a research ship. It was re-designated AGER-2 shortly before commissioning in May 1967. Following training operations off the U.S. West Coast, in November 1967, the *Pueblo* departed for the Far East to undertake electronic intelligence collection and other duties concerning the Soviet Union and North Korea. In late 1967, the *Pueblo* would meet its sister ship, *FP-345*, again at the U.S. Naval base in Yokosuka, Japan, prior to the fateful voyage that would intern the *Pueblo* in North Korea fifty-plus years later.[51]

THE INCIDENT

The eighty-three-member crew consisted of eighty-one sailors and two oceanographers to give cover that the ship was a research vessel. The ship was trailed by two fishing trawlers, *Rice Paddy* and *Rice Paddy 1*. Two

submarine chasers, four torpedo boats and two MiG fighters joined in the fray, harassing and ordering the *Pueblo* to halt. The ship was then fired on and ordered to follow the submarine chaser, with its signal flags stating to follow them. One casualty occurred during the fighting. An SOS was sent to American ships in the region, but no help came. Captain Bucher was helpless to do anything but save his men. When the *Pueblo* was ordered to follow the small North Korean vessels into Wonsan Harbor, Captain Bucher purposely slowed to a crawl to give the crew time to destroy the sensitive equipment and documents used to collect intelligence off the North Korean coast. Try as they might, a majority of documents and equipment remained accessible to the North Koreans once the ship was captured.[52] With the *Pueblo* at a crawl in North Korean territorial waters, the ship was boarded by North Korean officers and piloted the rest of the way to Wonsan.[53] The ship's crew was blindfolded, bound and looted of their personal belongings.

After reaching shore, the eighty-two blindfolded and bound men were marched in front of aggressive North Korean citizens, who shouted obscenities and spat at the American crew. They were kicked and punched mercilessly as the crowd shouted, "Death to the American bastards!"[54] The men were subsequently detained as prisoners of war for eleven months. They were tortured, kicked, punched and beaten during their captivity. As the ship's leader, Captain Lloyd Bucher was beaten, tortured and asked to sign a confession, which he consistently refused. At one point, the captain went through a mock firing squad and only capitulated on signing when the North Koreans threatened to shoot one crew member at a time until the confession was signed.

Late in 1968, during their confinement, "Hell Week" would become the prisoners' nightmare. Hell Week consisted of regular beatings after it was learned by the North Korean captors that the middle finger salute was *not* a Hawaiian good luck charm or greeting. The passive resistance was unveiled in a *Time* magazine front-page article showing a photo of the men sitting and listening to lectures on the virtues of socialism and the inherent, aggressive evils of the United States of America. Several had their middle fingers at their temples while listening. *Time* was bold in declaring how brave these men were and how foolish their North Korean captors looked. What resulted was a parade of terror on the prisoners with no let up. Richard Rogala, a crewman from the suburbs of Chicago, remembered being called to his cell door and kicked for no reason. He was then allowed to stand up and was subsequently punched in the face. Richard today has a set of false teeth because of the beatings he took.

FREEING OF THE PRISONERS

Two days before Christmas on December 23, 1968, the prisoners of the USS *Pueblo* were freed. They were loaded on buses and taken to a bridge. There, one by one, each of the *Pueblo* prisoners crossed the bridge into South Korea and was finally taken back home. After the prisoners were debriefed, they were greeted by their family, friends and loved ones. Captain Lloyd Bucher was set to face a United States naval inquiry. The inquiry recommended a court-martial due to the fact the ship was taken over without a fight and given that they failed to destroy classified information.[55] The recommendation to court-martial was dismissed. It wasn't until 1990 that the crew was awarded prisoner of war (POW) medals for their imprisonment inside North Korea.

Two months after the USS *Pueblo* prisoners were released, Commander Lloyd Bucher wrote a letter of gratitude the City of Kewaunee on February 24, 1969. It was addressed to Robert J. Albrecht, personnel manager of the Kewaunee Engineering Corporation:

> *Dear Mr. Albrecht, every man of the Pueblo's crew feels as strongly as I do. A warm gratitude to you for adding to the joy of our homecoming by welcoming us back. The Kewaunee Engineering Corporation, as the builders of the Pueblo has had a long association with our ship. All of us thank you very much for your kind letter and the enclosed pamphlets. I assure you that we all have studied these with great interest, also as you requested, the eighty-third coy was given to the Hodges family. (Seaman Eugene Hodges was mortally wounded in the capture).*
>
> *It is not just polite words, but the deepest truth when I tell you that in our months in North Korea, we never lost faith in our country and in the people of our country. We believed that Americans were working and praying daily for our release. We believed that our government was engaged in an urgent effort to affect that release. This trust helped us to keep steadfast and to endure. I know I speak for each one of the Pueblo's officers and men when I say that across the miles and the silence we felt your concern, and it strengthened us.*
>
> *The happiness of our return to our own land was heightened by warm welcomes. First, there was the reunion with our wives and children and parents. Then there was the welcome given us by many friends in San Diego whom we shall never have the privilege of knowing personally—people who lined the roads from the airports to wave as we went by and showing us they shared our joy. And then there are the expressions of welcome from*

Marine staff sargent Bob Chicca upon release from North Korea, 1968. *Library of Congress.*

USS *Pueblo* prisoners off the bus, 1968. *Library of Congress.*

friends like you, who sent cards and letters and telegrams to say, "Merry Christmas, you are home. We are glad."

We are, in spite of all that has happened to us, lucky men to have found such friendship.

Again, let me thank you for your consideration both in writing to me, and for forwarding to my crew the informative pamphlets on the birth of the USS Pueblo.

Thank you—from all of us.

Sincerely and gratefully,
*L*LOYD *M. B*UCHER*,*
Commander, United States Navy
On behalf of the officers
and men of the USS Pueblo

CHAPTER 10

STASI PRISONERS IN OUR MIDST

Werner Juretzko has served as an executive director for international affairs at the Cold War Museum in Washington, D.C., since 2003. He was also a founding member of the Midwest Chapter of the Cold War Museum in Milwaukee since its founding in 2004.

THE SPY NEXT DOOR

In 1945, Werner Juretzko found himself as a teenage boy conscripted into the local Hitler Youth in an area of Soviet-occupied Poland. He and his group were ordered to dig trenches to protect against the rapidly advancing Soviet army near his home in the oft-disputed region of Upper Silesia. Called on to halt the advance from the east, Werner and others in the Hitler Youth brigade conscripted by the Third Reich were the remaining few of the forces of lines protecting German-occupied territory from the Soviet advance. Sensing demise and taking advantage of an opportunity to escape, Werner, along with his sister, Frieda, trekked west to find safety out of the Soviet-occupied areas of Central Europe. They were quickly apprehended by Soviet occupation soldiers and impounded until the war concluded, serving in a Soviet POW camp as the Second World War ended. Frieda was harassed, raped and would die due to the actions of ruthless Soviet soldiers. Throughout this ordeal, Werner carried an internal hatred of the Soviet Union and its subsequent occupation of Germany.

In 1946, Werner fled the area of Soviet-occupied Poland trying to make his way to the west. He was fearful of arrest due to his outspoken anti-communist beliefs. He landed by train in the town of Kassel in the American zone, where he found a job as an apprentice in a heavy machinery plant. The German Communist Party's agitation and propaganda apparatus were in high gear at the time, trying to organize the plant's workers with little success. Juretzko's outspoken opposition soon drew the attention of the local criminal investigation section charged with combating political extremism of both right and left. He became an undercover operative and was instructed to change his view on communism—at least in public. The local communists would accept the new convert.

One of his first high-profile assignments was joining a peace group supported by East Germany and the communist Free German Youth, both of which were virulently anti-American. Among his duties in the so-called peace movement was to "ask" local businesses for "donations" to peaceful causes such as dispensing with western presence in Germany, as well as those efforts to support comrades fighting inside the Korean peninsula, caused by "aggressive imperialists." Among Werner's other activities was to ignite passions against the American occupation of Berlin by slashing tires, placing graffiti in public places and fomenting anti-American and western animosity in general. Internally, however, Werner kept police informed on upcoming demonstrations and the methods used by the East Germans to ship propaganda material to the West. United States G-2 military intelligence, which maintained a close liaison with the German police, liked Juretzko's diligence and recruited him as an agent in 1953. Juretzko kept his job as a master machinist, working to maintain a plausible identity to continue obtaining information and sources from the communist side.

JOINING THE GEHLEN ORGANIZATION

During the latter stages of the Second World War, German general Reinhard Gehlen was transferred to the G-2 army intelligence unit. Gehlen had been the head of Hitler's intelligence on the eastern front. The United States needed intelligence of Soviet and Soviet-occupied sources. In exchange for his removal as a war criminal, General Gehlen would supply his valuable intelligence and maintain a network through 1955. One of those then recruited to take part in activities in 1953 was Werner Juretzko. Thus began

a two-year stint working with the West during the early years of the Cold War. As a G-2 political undercover operative for U.S. Army Intelligence, Werner conducted authorized espionage missions behind the Iron Curtain. Werner would conduct missions of counting MiG-15 and MiG-17 Soviet fighter jets in airfields around Soviet/East German Air Force bases inside the Iron Curtain.

In early August 1955, Werner crossed through the Iron Curtain into East Germany on a bicycle. He is fond of pointing out the differences between his espionage activities and that of the famous U-2 pilot Francis Gary Powers, shot down over the Soviet Union in 1960 and subsequently held prisoner. Powers was given control of a (relatively speaking) $250 million aircraft, and Werner was given a 250 East German–Mark bicycle. That seventh spy mission behind the Iron Curtain proved to be the unlucky final foray that doomed him. He was caught at a hotel in Schwerin, East Germany—eating what evidence he could to destroy his culpability. Werner Juretzko, however, barely aged twenty-three, was destined to be confined to a communist dungeon.

After his apprehension by the East German Stasi while on an authorized mission in 1955, Werner was accused of, and tried for, anti-communist activities. He was tried and sentenced to thirteen years of incarceration for so-called crimes against the German Democratic Republic, Article 6 of its constitution. As a political prisoner, Werner spent six years of his imprisonment in the infamous underground torture chambers of the Stasi secret police in Berlin-Hohenschoenhausen, the notorious "Red Ox" in Halle and other barbaric inhumane prisons such as the Brandenburg-Goerden penitentiary. As a formality, according to his handlers in the West, Agent Werner Markus (aka Stanislaw Sowboda) failed to make contact with the G-2 organization on September 15, 1955, and was considered lost to the enemy. His action was taken by G-2 without prejudice, and in explanation, G-2 stated that the agent failed to maintain contact with G-2.

SERVING HIS PRISON SENTENCE

In October 1946, the KGB established an underground central detainment prison located at Hohenschoenhausen in East Berlin. Werner described his isolation and prison techniques of torture. One section of cells that lacked daylight was known to prisoners, guards and administrators alike as the so-

called "U-Boat" (named after the German submarine). His treatment as prisoner of the East German state included physical violence, psychological torture, being forced to stand and water cells. Disorientation, isolation, cold, heat, water and noise cells, along with a diet solely consisting of salty foods with the absence of water, were also implemented on Werner during his prison sentence. These were the most common physical tortures.

Werner recounts his worst day in prison, most notably the stress of what determination would be made regarding a death sentence or lengthy prison term. During the last days of November 1955, this underground KGB/Stasi interrogation cell in East Berlin held two men: Heinz Friedemann and Werner Juretzko. Only one of them would leave this Stasi prison cell alive. Werner was the fortunate one.

PRISONERS NOS. 12-2 AND 12-3

From here, Prisoner no. 12-2 and British Spy no. 554, Heinz Friedemann, was led to the guillotine and beheaded on December 22, 1955. The condemned was notified that his petition for mercy had been denied and that the execution would be carried out during the morning hours of December 22, 1955. The condemned remained calm in the face of this announcement, and when asked, he begged to be allowed to write to his family and to smoke. He also begged for something to eat. All his wishes were granted. The condemned spent the night smoking and writing. He kept calm all night and caused no problems. At 0255 hours, he was shackled and led into the execution room. There, in the presence of three comrades from the Stasi-Berlin and Comrade Dr. Skrobeck, chief medical examiner, as well as the warden, the verdict was briefly announced once more. Thereafter, he was handed over to the executioner. The execution lasted only about two seconds. On his death certificate, Friedemann's cause of death was listed as heart failure.

Prisoner no. 12-3, G-2 United States Army Intelligence operative Werner Juretzko, received a sentence of thirteen years and was transported to a maximum-security prison. Werner learned of his fate while being summoned to meet his interrogator. Instead of meeting his usual interrogator, however, he saw the largest human being he had ever met. Due to this Stasi officer's large hands, Werner assumed that he would meet his fate at the hands of a choker and be killed on the spot. Instead, he

learned of a long prison sentence. By his own account, Werner was thrown into an underground prison literally for stretches in solitary confinement without a gleam of daylight. He began a thirteen-year sentence that seemed like several lifetimes, stretched end to end, all terminated by new terror through punishment and interrogation—started anew by entry into one of the sixty-eight underground cells that had become the main interrogation prison of East Germany's State Security Police.

During his stay in various prisons, Werner shared his cell with a variety of prisoners of the former Wehrmacht, KGB/Stasi, East German prisoners and prisoners from other Iron Curtain countries. While communicating through the walls, he learned of a woman named Elli Barczatis. Werner was not aware of who Barczatis was at the time of his internment. In retrospect, she turned out to be the secretary to East German prime minister Otto Grotewohl; Barczatis had been passing secrets to the West. During the time of his imprisonment, Werner was very aware that a guillotine awaited Barczatis as part of a death sentence. Upon his release, Werner would tell his debriefers of the guillotine being used to execute prisoners of the East German state. In a state of disbelief, his debriefers had replied to Werner that he was not sent to the era of the French Revolution, as the guillotine was no longer used.

Returning after six years and two weeks from East Germany, stepping on Western soil again, Werner filed a two-word report with his debriefers: "Mission Accomplished." Werner eventually made his way to Chicago, studied engineering and went back into the machining occupation. For years, he would not discuss his background. Once the Berlin Wall fell, Werner made his way back to Berlin and demanded his and other prisoner records from the Stasi.

Major General Gerhard Niebling, deputy defense minister and coauthor of the 4+2 German unification treaty after the collapse of the German Democratic Republic, had been Friedemann's interrogator. Werner Juretzko filed murder charges against him after the fall of the Berlin Wall. When interviewed by a reporter of the *Berliner Post* about how he felt in light of Juretzko's charges, he replied, "I believe Juretzko is reading too many western detective stories!"

To this day, Werner Juretzko dedicates his presentations to the forty-six Western agents who were guillotined by the Stasi.

COLD WAR PRISONER OF WAR: THE SCHOOLTEACHER'S PAST

John Van Altena grew up as a farm kid from Milton, Wisconsin, a fifteen-minute drive away from my hometown of Janesville. Before reconnecting with John in 2004, I knew him simply as Mr. Van Altena. John was a German teacher at Franklin Junior High School in Janesville when I was in the seventh grade. It was my first year at the school, and I had Mr. Van Altena briefly as a homeroom teacher. On most occasions, I noticed him walking around the cafeteria during a lunch period or down the hallway between classes. To my seventh-grade self, he was just another teacher at the school. Other kids had mentioned that Mr. Van Altena had a run-in with the police in Germany at one point in his life but didn't think anything of it as there was no context for it. It was not until nearly fifteen years after attending seventh grade that I would fully understand just exactly what John Van Altena went through in the 1960s in a divided Cold War Germany.

EAST GERMAN STASI PRISONER REUNION

Francis Gary Powers Jr. was extended an invitation to a lecture on behalf of a Cold War history group I had formed in 2003. Gary was the founder of the Cold War Museum in Washington, D.C. The founding of the Cold War Museum was intended to honor his father's Cold War legacy as a U-2 pilot shot down over the Soviet Union in 1960, subsequent imprisonment and release in exchange for Soviet colonel Rudolf Abel. In order to recognize the heretofore unheralded stories of the Cold War era, the mission of the Cold War Museum expanded broadly to include several decades' worth of conflict with the Soviet Union. Gary Powers's invite spurred coordination of efforts and creation of the Midwest Chapter of the Cold War Museum.

As mentioned, I had reconnected with John Van Altena shortly before Gary's visit and discussed his Cold War history in East German Stasi prisons in the early 1960s. The Stasi was the East German secret police that kept that government's control over the population during the Cold War. Fortunately, John had written a book, *A Guest of the State*, in 1968 that recounted his capture, foray into the Stasi prison system and his eventual release. It was said that at any given time, the Stasi convinced one out of every sixty-seven people to become informants. Under communism, it was very lucrative to

give information to the state to get ahead. That might include a better job, a larger flat (or apartment), more rations and luxuries such as a television, washing machine or even a vehicle. The ability to snitch on a family member, neighbor, coworker, boss or other resident created an aura of suspicion that formed the basis of distrust among the population.

A surprise reunion took place because of the invitation of Gary Powers to lecture in Waukesha, Wisconsin. Gary had given me a contact in Chicago named Werner Juretzko to invite to his lecture at Carroll University while he was town. Werner had a peculiar past, as discussed previously in this chapter. Talking by telephone with Werner, in his thick German accent, he was exasperated when I mentioned John Van Altena's name. Werner had not seen John since about 1968, some thirty-six years prior. Both Werner and John had shared a history at East Berlin's notorious Hohenschoenhausen prison during the Cold War, albeit at different times and for different reasons. Werner served a stretch of time in the notorious prison from 1955 to 1961 for crimes against the state of East Germany. John and Werner had met by happenstance during John's book tour in 1968. Thereafter, they would visit each other's homes to share stories. Werner, a Chicagoan since 1962, when he immigrated to the United States, was invited to John's farm and recalled an amusing scenario visiting an American farm for the first time. As a city dweller, Werner was in need of farm attire and showed up to John's farm wearing boots, expecting to walk through cow manure. His first impression was memorable in that Werner walked inside the farmhouse and saw only books.[56] Werner's immediate thought was that John and his family must have been book farmers! Nonetheless, the Francis Gary Powers event with Werner and John was a reunion taken right out of the annals of *This Is Your Life*—rather astonishing given the short notice.

So how did John Van Altena, a farmer's son from the Midwest, come about his rendezvous with the Cold War? John began his German experience as a fifteen-year-old exchange student in high school in Goettingen, West Germany, in August 1960. The exchange was made possible by a University of Wisconsin professor of limnology whose family had a German exchange student staying with them. The university town of Goettingen was located about ten miles from the East German fortified "green border." Shortly after arriving in Goettingen for school, John had asked his host family if they would drive him to see the border. His host family father, Professor Rinck, was a law school professor in Goettingen, yet both he and his family were always resistant to taking John to the border. John quickly surmised that the family was either ashamed or had other personal reasons for not wishing

to make the excursion. Three months into his stay, John had met another American student at the law school. This introduction took place during a party hosted by John's host father. It was through this friend that John finally got his wish to see the East German border. His first sight of the heavily fortified border made an immediate impression. Barbed wire, gun towers, tilled minefields and spotlights out in the beautiful wooded rural landscape filled John with awe. His acquaintance with this relic of the Cold War was the beginning of an ongoing saga.

The next chapter of John's road to Cold War history would occur while returning home one year later in August 1961 from his year in Goettingen, along with his exchange brother, Christian. John was the only non-German on board the ship. They had booked passage by boat back to the United States on a German coal freighter that was making its maiden voyage to Norfolk, Virginia, to load coal bound for the Netherlands. The freighter was allowed to have no more than twelve passengers by maritime law without a doctor on board. As passengers, the boys ate with the captain and the other officers. The trip was delightful until about halfway through the voyage. While en route to the United States, the captain announced the turmoil in Berlin that was leading up to and resulting in the erection of the Berlin Wall, the barrier against the free-flowing border between East and West Berlin. Thousands were fleeing the East for a chance to improve their lot in life in the West. John and his exchange brother, Christian, counted themselves fortunate to be located in the middle of the Atlantic Ocean given the possible confrontation between the United States and Soviet Union in Berlin. The following day, the Berlin Wall was up. The first version of the wall was erected on short notice in secrecy, which kept the United States and its allies off balance. The wall was created with brick and mortar, in addition to barbed wire. The boat was then turned around and returned to Germany since the United States halted all transportation to its country.

During his second year of college at the University of Wisconsin–Madison, John decided to return to study in West Germany. He would attend law school at the Free University of Berlin in 1964. He took a job with Lufthansa Airlines in Hamburg in the summer of 1964 before school began to make money for tuition and expenses during the school year. During this time in West Germany, he befriended a coworker whose cousins wished to escape to the West from East Berlin, and John agreed to become part of the attempt.

The cousins were a couple named Jurgen and Baerbel Rabe, who had made an unsuccessful attempt previously. The couple also wished safe

passage for their young daughter, Sabrina. The pieces were in place to make a smooth escape through the border, as one of the associates had clearance as a government employee in East Berlin. An old Ford vehicle, with the gas tank hollowed out, would act as the escape car. The extent to which people would go to escape communism was astounding. The compact area would hold the mother, Baerbel, and her daughter, Sabrina, for the journey to freedom in the West. The father, Jurgen, would make his way out at a different time, on the following day.[57]

After a series of test runs, the organizers, including John, who would drive the vehicle, deemed the mission as having a safe enough chance at success to proceed. Sabrina was given a small tranquilizer dosage to keep her quiet during the border crossing. But something was amiss when John reached the border. There was an unusual number of Soviet police cars waiting at the border crossing. They were waiting for John and his cargo, as the authorities were working on a tip they had received within the past twenty-four hours. A family member had given up the names of the escapees.

John was ordered to exit from the vehicle as it was searched. As Baerbel and Sabrina were about to be found in the vehicle, John walked toward the Americans at crossing point to West Berlin. The American soldiers had arrived in a jeep with a gun turret, telling John that he should walk toward them. As John prepared to walk toward the American sector, a Soviet officer cocked and aimed his service pistol at John's back, kindly telling him to stop or else he would be shot. John obliged, and what transpired over the next eighteen months was an ordeal that would transform his life forever.

JOHN'S LIFE INSIDE A STASI PRISON

Prison time in East Berlin was a nightmare. John was given an eight-year sentence in a country that the United States had no diplomatic relations with in 1964. The United States recognized West Germany as of 1955, but East Germany was a Warsaw Pact country the United States would not recognize until 1974. As such, it was especially difficult to secure any type of release during his time in prison. Oftentimes an unofficial representative, Maxwell Rabb, who was negotiating his release, would show up to talk with John, only to find the American prisoner "unavailable." John mentioned later that these moments coincided with prison officials taking him on long drives into the countryside for a few days at a time at little to no notice.

During his time in prison, John had served varying moments with prisoners as well as many months in solitary confinement. He learned that the prison housed a significant number of prisoners convicted of smuggling refugees. He was suspicious of several of his prison mates since there was no way to tell if they were informants or friendly. Under the circumstances, it was nice to have someone to talk to other than having guards flip his cell door peephole on a regular basis. John noted that he passed the time with rockets made of toothpaste and matches and chess pieces made from bread, as well as smoking cigarettes. With or without a roommate, John learned to tap on the prison walls and communicate with others incarcerated for ferrying refugees out of the country, with no end in sight for their prison terms. Many were waiting for East German leader Walter Ulbricht to kick the bucket, as many prisoners are released upon the death of a leader.

John was never mishandled by his interrogators, but on at least two occasions, his handlers were irate about his involvement in activities and acquaintances that had not been discussed. The first incident of anger and frustration on the part of the East Germans involved John's Peace Corps training that had not been disclosed. The Peace Corps was formed in part to be the eyes and ears of the United States in places where the government did not have much information. According to John, those efforts became futile because it often put otherwise peaceful volunteers in harm's way.

What was striking about John's situation was how the information was found. The East Germans, always known for their meticulous methods, had located a newspaper article detailing John's involvement from a small-town newspaper in an era that did not have access to the Internet.

The second incident that angered John's handlers involved a family friend who had known John since he was a child. Joe Hurka was a neighbor who had escaped Czechoslovakia with a MiG fighter jet, landing the aircraft in West Germany in 1955. John's mother had written a letter indicating that Joe was over for dinner during a recent evening and sent along best wishes

Milton Junction Man Held by Communist East Germans

BERLIN (UPI)—Communist East German police have arrested one American in East Berlin and released another, American officials said Friday.

They said John Van Altena, 21, of Milton Junction, Wis., was arrested by Communist police Oct. 10 for allegedly trying to help refugees escape.

Van Altena is the son of Mr. and Mrs. John P. Van Altena, Rt. 1, Milton Junction. His father is a farmer.

Van Altena is a 1961 graduate of Milton Union High school. He studied in Goettingen, Germany, during his junior year. He attended the University of Wisconsin for 1½ years. Before his arrest, he had been working for Lufthansa German Airlines in Germany.

Details of the arrest were not known.

Meanwhile, American officials disclosed the release of another American who had been arrested by the Communists.

He was Roy Jacobs, 25, of Detroit, Mich.

Officials said Jacobs was arrested in East Berlin last year, sentenced to 18 months in a secret trial and released early this month.

The charges were not disclosed.

Van Altena was said to be the only American still in East German custody.

In the past, Western nationals arrested on similar charges were tried and sentenced to terms as high as three years.

John Van Altena returns home. From the *Wisconsin State Journal*, October 31, 1965.

Maxwell Rabb, Secretary of State Dean Rusk and John Van Altena in 1965. *John Van Altena.*

to John. It was strange for John to see a letter written by his mother, as John never received any letters while imprisoned. Communications were kept from John to make him feel more isolated. The East Germans, again meticulous in their research and methodology, connected the dots with Joe Hurka. The communists never forgot those who abdicated their socialist responsibilities, especially those pilots with multimillion-dollar military aircraft handed to the West.

One day in 1965, John was called up to speak with his handler. He asked John if he would like to enjoy a beer in West Berlin that evening. John laughed and thought his handler was kidding. But the time had come to be released from prison. In total, John spent eighteen months at Hohenschoenhausen prison. In March 1965, John was taken from confinement in a brand-new Mercedes by Maxwell Rabb, his negotiator. This time, the Mercedes sped through another border crossing without stopping, met only by a quick salute by East German soldiers manning the gate for access to the West. John was finally free.

John Van Altena was invited to a reception in 1965 with the president of the United States, Lyndon Johnson. Vice President Hubert Humphrey

was at the White House on the date of the reception, with John only being told that President Johnson had a commitment and might not attend. It turned out that President Johnson was making a major decision regarding the Vietnam War. Notably, the decision involved the mining of Haiphong Harbor that could be used to bomb not only North Vietnamese ships but also Soviet and Chinese vessels supporting the communist North Vietnam in its war against the United States. The president, John surmised, had a good reason for attending the other meeting after learning later about the meeting's significance.

Although John's prison sentence in East Germany ended his involvement in seminal Cold War moments, it would continue in yet another form after the prison saga. This time, he and his family would witness the explosion of an American B-52 bomber making a training run over his family's farm in Stone Lake, Wisconsin, in 1966 (discussed earlier). Slightly over a year after John was released, he and his family were on a hunting trip at the farmhouse. Everyone was stunned after hearing and seeing an explosion just a few short miles away. John and his family joked that their gas heated stove was ripe for exploding after witnessing their father attempting to light it on several occasions. But this explosion was feared to be a nuclear bomb given the times. After investigating the scene for survivors, John and his family scoured the area before being interrogated by the United States Air Force. It was learned that nine airmen lost their lives in the explosion.

John would eventually return to West Germany to complete his law degree. He never took up the East German captain's offer to return to East Berlin to visit. John would go on to work with another airline, become a translator and eventually go into teaching for school districts in Elkhorn and Janesville, Wisconsin. He would also return to his family's farm, raise crops and horses and restore native plants and vegetation to his wetlands.

CHAPTER 11

A SAFE HOUSE IN MILWAUKEE

Milwaukee's unique Safe House restaurant was a creation of David Baldwin in 1967. He held the distinction of being station chief for forty-eight years before retiring in 2015. The restaurant concept grew out of the same period that the James Bond 007 franchise was catching the country and world by storm. Thus the idea of having a spy-themed restaurant on the heels of Hollywood's most popular secret agent took off. The restaurant took on a life of its own, as millions of customers have walked through its doors over the years. But David was quick to point out that the experiences and décor were an ever-evolving creation of not only himself but also the staff and his wife, Shauna.

David came of age amid the Cold War era, notably as a United States Army veteran. At one point, he served as a drill sergeant during the Korean War era in the 1950s. David's service came during a time of integration in the armed forces, as segregated units existed up through the Second World War. After leaving the service, David worked in stints as a ballroom dance instructor and a model, as well as putting his law degree to use. He and other partners opened a popular nightclub called Whisky A-Go-Go. Before long, David would take sole control and would soon transform the nightclub establishment into the Safe House.

Fittingly enough, the Safe House, with no traditional markings or advertisement and working solely on word of mouth, is located on Front Street. Front Street is the shortest street in Milwaukee. To get inside the Safe House, a prospective "agent" needs to recite a password to the gatekeeper

of the establishment. An unwritten rule with the city of Milwaukee has continued to be honored: nobody can share the password. If you make it inside (and, conversely, find a way out), you will find a labyrinth of puzzles and props, a testament to spy craft and an endeavor with a recorded history found in the Bible.

A BIBLICAL BEGINNING: CREATION OF A SPY AND THE ORIGINS OF A SAFE HOUSE

One need only look as far as the nearest Bible to find the earliest records of the spy and a subsequent need for a safe house. As recorded in the book of Numbers, chapter 13:

> *MOSES SENDS OUT 12 SPIES*
> *The LORD said to Moses,* [2] *"Send men to explore Canaan, which I'm giving to the Israelites. Send one leader from each of their ancestors' tribes."*
> [3] *So at the LORD's command, Moses sent these men from the Desert of Paran. All of them were leaders of the Israelites…*
> [17] *When Moses sent them to explore Canaan, he told them, "Go through the Negev and then into the mountain region.* [18] *See what the land is like and whether the people living there are strong or weak, few or many.* [19] *Is the land they live in good or bad? Do their cities have walls around them or not?* [20] *Is the soil rich or poor? Does the land have trees or not? Do your best to bring back some fruit from the land."*[58]

After forty days, these men returned and reported their findings, making this the oldest reported spy mission in the world and on record as the world's second-oldest profession. And as we can see from this Bible lesson, the occupation of a spy was a creation from God—perhaps the only occupation created by God.

A "Safe House" was also on record in Joshua, chapter 2:

> *RAHAB AND THE SPIES*
> *Then Joshua son of Nun secretly sent two spies from Shittim. "Go, look over the land," he said, "especially Jericho." So they went and entered the house of a prostitute named Rahab and stayed there.*
> [2] *The king of Jericho was told, "Look, some of the Israelites have come here tonight to spy out the land."* [3] *So the king of Jericho sent this message*

to Rahab: "Bring out the men who came to you and entered your house, because they have come to spy out the whole land."
[4] *But the woman had taken the two men and hidden them. She said, "Yes, the men came to me, but I did not know where they had come from.* [5] *At dusk, when it was time to close the city gate, they left. I don't know which way they went. Go after them quickly. You may catch up with them."*

THE MEANING OF MILWAUKEE'S SAFE HOUSE AND ITS CONTENTS

In an interview for this book, Shauna Baldwin, widow of David Baldwin, gave insight to how she and David provided the theme of inclusiveness for the Safe House. No agents or prospective agents are ever turned away. Shauna touched on the absurdities presented by contrasting the Soviet Union and the United States of America. Showing your papers at every turn was one such example of turning the tables on the Soviets. As mentioned, to enter the Safe House, a prospective agent needs a password. However, if people do not possess knowledge of the password, the prospective agents may need to prove their worthiness by undertaking an action of sorts. If the absurd exercise concludes satisfactorily, clearance will be granted and the agents will be admitted. Be sure to smile while undertaking the examination.

Another example antithetical to the Soviet communist system and satirized in the Safe House is spying or testifying against your friends, coworkers or loved ones in exchange for preferential treatment. As in the case of many closed societies overseen by tyrants, one way to get ahead is to give information on "enemies" or "sympathizers" in your midst. In the Soviet Union, the downfall of socialism and communism in practice was often blamed on "saboteurs" or capitalists undermining the utopian society. By using simple props in the Safe House, however, agents can "spy" on their fellow agents in a variety of ways.

The Safe House in Milwaukee is always ready to provide a "cover" and an alibi for its guests. It is a place where the customer can take a break from the outside world, enjoy time with friends or family with a drink and a meal and escape into the world of intrigue. At the Safe House, oftentimes fact is much stranger than fiction, sometimes literally. Reportedly, there was a real-life incident decades ago, with the FBI chasing down a wanted man. The suspect slipped into the Safe House to avoid capture. Like each customer, when using the Safe House entrance, the FBI agent saw only a woman sitting

at a desk. She could not verify whether she had or had not seen an individual enter the premises. The result was that the suspect got away through one of the unmarked exits. Apparently, the coincidence of a suspect shaking off a pursuer within a Safe House was not found amusing to the agent.

Another element to the Safe House, added in 2000, was the refurbishing of a dining room into the adjacent Newsroom Pub. The Newsroom Pub has been home to the Milwaukee Press Club since then and, along with it, the signed autographs from presidents, governors and other politicians on down who have spoken there. Professional athletes, writers, actors and actresses' names also don the walls. But as a firm believer in the United States Constitution, and fellow veteran, David was especially proud of the many veterans who stopped by to visit the Safe House. He routinely hosted gatherings of Medal of Honor winners at the Safe House, and through his last days, he honored Wisconsin men and women who died in combat during tours in Iraq and Afghanistan. A wall poster created for those who gave the ultimate sacrifice is in the Newsroom Pub. David Baldwin held the Constitution of the United States very dear, so much so that he dedicated much time and effort to creating an American Freedom Center up until passing away in December 2015.

One of the most sobering exhibits at the Safe House is the East German Stasi prison cell door, located in the German dining sector. While perusing exhibits and memorabilia inside the Safe House or dining in the German sector, agents will pass through Checkpoint Charlie and a large piece of the Berlin Wall. What may be unfamiliar to many is the significance of the door itself. On permanent loan from the Cold War Museum, the Stasi cell door was brought to the United States from Hohenschoenhausen prison in what was East Berlin.

As noted in chapter 10, the cell door was in Hohenschoenhausen prison, where Werner Juretzko and John Van Altena served prison time in East Germany. The cell door is adjacent to the one depicted in the 2015 movie *Bridge of Spies*, starring Tom Hanks and directed by Steven Spielberg. In the movie, Tom Hanks's character, John Donovan, is placed in custody overnight while traveling inside East Berlin to negotiate the release of U-2 pilot Francis Gary Powers.

The Stasi prison cell door in the Safe House was visited by two notable Soviets. Sergei Khrushchev, son of Soviet leader Nikita Khrushchev, was one such dignitary. Sergei was a guest of the Cold War Museum Midwest Chapter in 2006, cosponsored by the Safe House. A few years later, KGB general Oleg Kalugin visited the Safe House while in town giving a talk

to the FBI. Oleg Kalugin was the highest-ranking KGB defector to the United States. Kalugin, a counterintelligence agent and onetime superior of Vladimir Putin's, and former prisoner Werner Juretzko once stood in front of the cell door, discussing times past as both individuals were foes during the Cold War era. In a twist of destiny, both Sergei Khrushchev and Oleg Kalugin became United States citizens. These two former enemies of the United States, sworn to uphold the laws of the Soviet Union, became citizens of the nation they had vowed to destroy.

Even with the Cold War officially over with the dissolution of the Soviet empire, David Baldwin was aware of the eternal allure of intrigue and spy craft when molding the Safe House. The Safe House continues in good hands, and prior to David's passing in 2015, the establishment was sold to the Marcus Corporation. A second Safe House was opened in Chicago in March 2017.

CHAPTER 12
COLD WAR PERSONALITIES

GENERAL DOUGLAS MACARTHUR

Douglas MacArthur called Milwaukee home. During the outbreak of the Korean War, MacArthur would invoke that Korean winters were as severe as those "in my native state of Wisconsin."[59] Douglas MacArthur had a long, storied family legacy in Wisconsin. His grandfather Arthur MacArthur Sr. served as a city attorney in Milwaukee, as well as a State of Wisconsin and District of Columbia judge. Arthur Sr. also served briefly as the state's governor in 1856. Arthur MacArthur Jr., a Civil War hero, was Douglas's father. Douglas's stint in Wisconsin would begin while he was appointed to serve in Milwaukee as part of the Army Corps of Engineers as an officer, starting in 1907. For years, his official address was listed as the Plankinton Hotel in Milwaukee.[60] After leaving in 1912 for another army assignment, Douglas MacArthur would not return to Milwaukee until his speaking tour after being relieved of his command in the Korean War by Harry Truman in 1951. Estimates ranged upward of 1 million people lining the streets to welcome Wisconsin's "native" son. Douglas died at Walter Reed Army Medical Hospital in 1964. A plaque commemorates his residence at what is now the Shoppes of Grand Avenue in downtown Milwaukee. On June 8, 1979, the general's widow, Jean MacArthur, unveiled a statue of the general at the dedication ceremony in MacArthur Square in Milwaukee. The statue is now located at Veterans Park along the lakefront.

General Douglas MacArthur. *Library of Congress*.

IRAN-CONTRA AND THE DOWNING OF AN AMERICAN IN NICARAGUA: EUGENE HASENFUS

The Iran-Contra affair was a seminal moment in Cold War history in the 1980s. The Sandinista government in Nicaragua took charge after deposing the dictator Antonio Somoza in 1979. In his anti-communist crusade, Ronald Reagan backed the Contras in Nicaragua, fighting against the pro-Marxist Sandinista government. When Democrats in Congress blocked the funding of these "freedom fighters," the Reagan administration sought other ways to support the Contras. A plan was then hatched to sell arms (notably tube-fired anti-tank and anti-aircraft missiles) to Iran in exchange for its help securing the release of American hostages in the Middle East. Iran was embroiled in a war with its neighbor, Iraq, led by Saddam Hussein at that time. The proceeds of these arms sales were then funneled to assist the Contras in Nicaragua.

Eugene Hasenfus, a former Marine of Marinette, Wisconsin, would be at the center of the incident. A cargo plane carrying weapons intended for the Contras was shot down by the Sandinistas on October 5, 1986. Hasenfus was the only survivor. He was tried and convicted in Nicaragua, and on November 15, 1986, he was sentenced to thirty years in prison for terrorism and other charges. He was released in December that year.[61]

A FUTURE ISRAELI PRIME MINISTER WITH MILWAUKEE ROOTS

Golda Meir was not only a champion of Israel but also woman revered for her strength. Born in 1898, Meir did not recall many memories of growing up in Kiev, Ukraine. At that time, Ukraine was part of the Russian empire, and hers was a destitute childhood with her Jewish family. She knew that there was not much to eat and had poor living arrangements. A few years after her father left for the United States, Golda would follow by immigrating to Milwaukee in 1906 with her mother and sisters.[62]

Her first memories of her new city of Milwaukee drew her into the colorful sounds and bustling street life, watching with awe the cars, trolleys and bicycles zipping by on the streets. Jewish refugees had settled in small area of the city, and she would attend the Fourth Street School from 1906 to 1912. According to the Milwaukee Public Schools website, she visited the school on a trip back to Milwaukee in 1969, telling children:

Israeli prime minister Golda Meir. *Library of Congress.*

> *It isn't really important to decide when you are very young just exactly what want to become when you grow up. It is much more important to decide on the way you want to live. If you are going to be honest with yourself and honest with your friends, if you are going to get involved with causes which are good for others, not only for yourselves, then it seems to me that that is sufficient, and maybe what you will be is only a matter of chance.*

The school would change its name to honor Golda Meir in 1979.[63]

Golda would live in Milwaukee until 1924, when she and her husband, Morris Meyerson, immigrated to Palestine before moving on to Jerusalem. She was active in politics her entire life, dedicated to the Labor movement as well as the creation of a permanent state of Israel. Golda Meir had the distinction of holding the first passport issued by Israel and was appointed as first ambassador to the Soviet Union in 1948. She would be welcomed personally by Stalin five months later when the USSR was the second country, behind the United States, to recognize Israel as a country in 1948. The Soviet Union was one of the first countries to recognize the state of Israel despite efforts within the USSR to discriminate against the Jewish population. Josef Stalin was more interested in gaining influence in the Middle East, as money was pouring into Israel from Jewish families abroad, especially from the United States. Golda Meir would be instrumental in raising funds abroad, especially from her former home country.

Reluctantly, Golda Meir would become prime minister of Israel in 1969 upon the sudden death of Levi Eshkol. During her tenure, she would endure the Munich Olympic bombing and the Yom Kippur War in 1973. She would resign the following year. Golda Meir would pass away at the age of eighty.

CHAPTER 13

TERROR IN MADISON

STERLING HALL EXPLOSION

In the 1950s, Madison was a largely quiet, quintessential midwestern Wisconsin university town. South-central Wisconsin had always been dominated by farming and manufacturing communities that would earn the Badger State residents the reputation as "cheeseheads." After the Second World War, couples got married, had children, went to church, bought a home, worked at the plant and grew old together. As the 1960s came, that typical midwestern persona would change as the civil rights era protests evolved into demonstrations against the Vietnam War. The University of Wisconsin–Madison became a magnet for protesters and protests, most of them peaceful, but the movement that attracted revolutionary types would eventually turn the demonstrations and situation deadly. Dow Chemical, which produced napalm used in the jungles of Vietnam and Southeast Asia, attracted widespread protests in the fall of 1967. Dow Chemical was interviewing prospective employees at the Commerce Building on campus. Two years later, the most seminal violent antiwar action took place when Sterling Hall was bombed by radicals, a group led by two Madison brothers that would become known as the "New Year's Gang" in 1969.[64]

TERROR IN MADISON DURING THE VIETNAM WAR

The Vietnam War would become one of the most contentious conflicts in American history. As Containment Policy author George Kennan's

foreign policy template, communist aggression in Southeast Asia dictated that communist expansion should be met head on as a counteracting force wherever those conflicts should arise. Hence, not sparing an inch or recognition to the North Vietnamese led by communist Ho Chi Minh, America sent in covert support during the French fall of Dien Bien Phu in 1954. After the French colonial powers withdrew from what would become communist North Vietnam, the United States sent advisors to South Vietnam in its fight against the North. At its height, the Vietnam War would see more than 500,000 American men and women serving in the Vietnam War from 1965 to 1975. The war would spread to and affect neighboring countries of Thailand, Laos and Cambodia.

The conflict would be met with protests at home all over the United States; the University of Wisconsin–Madison was no exception. At a time when the voting age was twenty-one, many students were directly affected by the war since a compulsory draft determined which men would serve during wartime. In 1973, hostilities of the Vietnam War ended with an armistice brokered by Secretary of State Henry Kissinger. The North Vietnamese would dishonor the agreement by invading and overtaking South Vietnam in 1975, actions that culminated in the hostile takeover of Vietnam by the communists. Many Vietnamese, Thai, Laotians and Cambodians would immigrate to the United States, including large numbers to Wisconsin, after the Vietnam War ended. More than fifty-six thousand men and women are listed on the Vietnam War Memorial in Washington, D.C.

The Sterling Hall building housed the Army Mathematics Research Center, which proved a direct target as a connection to the Vietnam War effort. As such, it justified the radical New Year's Gang to step up a violent response during the tense period. However, despite the group undertaking the bombing of Sterling Hall early in the morning, several researchers were using the facility. None of the researchers present in Sterling Hall had projects related to the Vietnam War, being fought several thousand miles away. The radicals behind the bombing were not aware that anyone was in the building. One researcher, thirty-three-year-old Robert Fassnacht, was killed in the building at 3:42 a.m. on August 24, 1970. Several other researchers in Sterling Hall were injured. Millions of dollars in damage was done to Sterling Hall and nearby buildings and property. The explosives were placed in a Ford van that men had stolen from a professor. It was packed with ammonium nitrate and other chemicals. Brothers Karleton and Dwight Armstrong, along with fellow students David Fine and Leo

Burt, were among the men involved in the bombing. All would land on the FBI's "Most Wanted" list after fleeing authorities.

Two of the college students, Karleton and Dwight, were brothers who grew up in the normally peaceful city of Madison. An acquaintance of mine, who did not wish to be identified in this account, grew up down the street from the Armstrong boys. She was friends with their younger sister, Lorene, whom she knew primarily from Girl Scouts and the neighborhood. The older boys, Karleton and Dwight, were remembered as typical boys growing up next door who attended school together, played catch in the backyard and rode their bikes around town. Karl and Dwight would go on to attend the University of Wisconsin–Madison, which during the 1960s attracted students from outside the district who came with their radical ideas. My acquaintance, who also attended University of Wisconsin–Madison during the era, would recall students bused into the city during the Dow Chemical demonstrations when she was a freshman taking an English class in 1967, when the sit-ins took place. My acquaintance also identified the most outspoken students as being from Students for a Democratic Society (SDS) and other radical organized groups from Berkeley, California.

When the Vietnam War kicked into high gear, the Armstrong boys would meet members of these types of groups, which wanted to undermine the war effort in a more direct, radical fashion. The Sterling Hall bombing would not be the first time the Armstrong brothers were involved in terrorist activities designed to interrupt the Vietnam War on the homefront. The New Year's Gang was responsible for lobbing firebombs at the Selective Service Office and the ROTC building on the University of Wisconsin–Madison campus.[65]

Several miles east of Madison, the city of Sauk Prairie was home to the Badger Army Ammunition Plant. Badger Ordnance was activated from during the Second World War as an ammunition manufacturer and went back online during times of conflict, mainly during the large-scale escalation and involvement in the Korean and Vietnam Wars.

Dwight and Karl decided to steal a Cessna 150. On December 29, 1969, they conducted an air bombing campaign of their own. While Dwight piloted the aircraft, Karl dropped a series of explosive-filled jars, which failed to detonate, on the Badger Army Ammunition Plant. A getaway car waited at the Sauk Prairie Airport, and the brothers escaped. The Badger Army Ammunition Plant bombing was said to be the first bombing of an American target since Pearl Harbor in 1941. Due to the upcoming New Year, the group headed by the Armstrong brothers would be given the moniker of "New Year's Gang."[66]

AFTERMATH OF STERLING HALL BOMBING

According to Sauk County sheriff's deputy Dan Hill, on duty on August 24, he pulled over a vehicle containing the four young men who fit the descriptions of the bombers. Because of the lack of an outstanding warrant, a Sheriff's Department shift change and the Madison Police Department being tied up with the bombing, the suspects were let go. After fleeing to Canada, three of the college students were arrested, tried and convicted for their role of the Sterling Hall bombing. Despite an international manhunt for each of the suspects, Leo Burt continues to be at large as of the publication of this book. A $150,000 reward is still in effect from the FBI for Burt's capture. Some thought that Leo Burt was the Unabomber. Burt is now also considered the longest-running at-large FBI fugitive as of this printing.

Dwight died of lung cancer in 2010. In an interview with the *Wisconsin Capitol Times* in 1992, Dwight stated his reason for being involved in the bombing: "I mean, something had to be done, something dramatic, something that showed people were willing to escalate this at home as far as they were willing to escalate it in Vietnam."[67]

Karl Armstrong served seven years of an original twenty-three-year prison sentence and was released in 1980. He continued having run-ins with the law. In 2012, Karl was arrested following a traffic stop in which $800,000 was found in a motorhome he was driving. Marijuana was suspected to be involved with the money.[68]

David Fine was captured in California after nearly six years on the run from law enforcement. He served three years of a seven-year sentence. He passed the bar exam in the state of Oregon in 1984 but was denied admission to the bar due to lack of moral candor.[69]

CHAPTER 14

MILITARY BASES IN WISCONSIN DURING THE COLD WAR

PROJECT ELF IN WISCONSIN

The Project ELF (Extreme Low Frequency) system was a scaled-down version of Project Sanguine, a United States Navy program that envisioned communication with submarines through the earth's core. This communication system would have allowed Trident ballistic missile submarines to get close enough to the USSR to launch a sneak attack or first-strike with nuclear weapons. The original project was scaled back considerably when it was deemed too ambitious, given the size of land required to deploy the antenna (six thousand miles of cable would have been needed). In 1969, the navy constructed the ELF Test Facility in the Chequamegon National Forest south of Clam Lake, Wisconsin. The test facility consisted of twenty-eight miles of antenna cable strung aboveground on poles. This antenna was in two segments of fourteen miles each that were laid out in the form of a cross to provide bidirectional transmission.[70] There was environmental concern about electromagnetic field exposure. For years, the site was protested and demonstrated against. Five times since 1984, antenna poles have been cut down by activists who temporarily shut off the system. After determining that ELF was outdated and unnecessary, the United States Navy shut down the facility at Clam Lake.[71]

U.S. Navy personnel at the ELF system site. *Library of Congress.*

LIST OF MILITARY BASES AND FACILITIES IN WISCONSIN DURING THE COLD WAR

128TH AIR REFUELING GROUP MILWAUKEE
Formerly 128th Fighter Group 1946

VOLK FIELD AIR NATIONAL GUARD SITE
Camp Williams, Wisconsin National Guard site, part of Volk Field

FORT MCCOY
Training center during Korean War 1950–53
Reactivated as permanent training center 1973

OSCEOLA AIR FORCE STATION 1951–75
Gap Filler Site at Jim Falls, WI (P-35C)

TWO CREEKS AIR FORCE STATION, 1954–57
Nike missile radar site, 1957–59
Gap filler site until 1968

RICHARD I. BONG AIR FORCE BASE, KANSASVILLE, WI
Never completed. Assigned to Strategic Air Command in 1956

ANTIGO AIR FORCE STATION 676TH RADAR SQUADRON
Antigo AFS, Wisconsin, June 1, 1964–April 1, 1966
755th Aircraft Control and Warning Squadron (later 755th Radar Squadron)
Williams Bay AFS, Wisconsin, June 1, 1959–April 1, 1960[72]

There were Nike Missile locations in the Milwaukee area (see chapter 6 for more details):

- M-02 Brown Deer Road 1957–71
- M-20 Harbor Drive 1957–71
- M-42 City of Cudahy 1956–61
- M-54 City of Hales Corners 1956–61
- M-64 City of Muskego 1956–63
- M-74 City of Waukesha 1956–71
- M-86 Village of Lannon 1956–58
- M-96 Silver Spring Drive 1956–63

Note that MS-20, part of the Minneapolis–St. Paul Nike system, was in Roberts, Wisconsin.

BADGER ARMY AMMUNITION PLANT
Sauk Prairie, Wisconsin

The Badger Army Ammunition Plant, also known as Badger Ordnance Works, was built in 1943 during the Second World War. Its purpose was to manufacture propellants, explosives and chemical materials. Due to men being deployed during the war to European and Pacific Theaters, most of the workforce consisted of women. The workforce at its peak numbered about 6,600. With the war ending, the plant was shut down in 1945. The plant would open and close at different times over the decades, with various wars sparking a reactivation.

Standby status resumed until the Korean War, when the plant was reactivated in 1951, producing 268 million tons of powder for the war effort. Employment peaked at just over 5,000 persons throughout 1958, when the plant again was shut down and placed on standby status until 1966. The Vietnam War caused the plant to reactivate, and it would

Badger Army Ammunition Plant. *Library of Congress.*

run for another ten years. Peak employment during the Vietnam War era would reach close to 5,400 persons.[73] This era also saw the bombing run of brothers Karl and Dwight Armstrong, who stole a plane and unsuccessfully firebombed the plant in 1969. The plant today has seen witnessed efforts to clean up contaminants and revert the area to the flowing prairie farmlands that dominated the region before the plant was built to support various wars.[74]

Oshkosh Truck (Oshkosh, Wisconsin) and the Amron Corporation (Waukesha, Wisconsin) are just two of many contractors that existed during the Cold War era supporting the United States armed forces. Oshkosh Truck provided the first aerial and rescue firefighting truck for the United States Coast Guard in 1953. Oshkosh also produced aircraft tow tractors, designing and building the U-30, forty-five of which were built for the U.S. Air Force to tow the Lockheed C-5 Galaxy transport aircraft.

In 1976, the company won a U.S. Army contract to supply 744 M911 heavy equipment transporters, the first in a long line of U.S. Army contracts that now sees Oshkosh Defense as the sole supplier of medium and heavy tactical trucks to the U.S. Army and Marine Corps.[75]

The Amron Corporation supplied a variety of war matériel during the Cold War. Shell casings, cartridges, grenades, fuses, projectiles and even ejection seats were produced at the Amron Corporation. Kenneth Tapper started the Amron Corporation in 1955 and worked at the company until 1979. His widow, Virginia Tapper, served as an early consultant to the Cold War Museum Midwest Chapter.[76] Virginia passed away in 2008.

CHAPTER 15
LEGACY OF THE COLD WAR

THE COLD WAR TODAY

The Cold War is still with us. Barely a day goes by when North Korea is launching another missile. In 2018, Donald Trump became the first U.S. president to meet directly with a North Korean leader. Talks were held with Kim Jong-un to forge a path to the denuclearization of the Korean Peninsula. Russia under Vladimir Putin, a former Soviet KGB officer, continues to spark tensions with the United States. Excursions into international waters and airspace have been ramped up in recent years by the Russian air force and navy, reminiscent of the Cold War era that would bear witness to Soviet military aircraft and submarines test American and other western nations' border response. Poisonings of former KGB agents and political enemies have been suspected in several cases. After nearly sixty years, a Castro, whether Fidel or Raul, will not oversee modern-day Cuba. China continues to grow larger and has established a more dominant position both economically and militarily in Asia and around the world. The Chinese Communist Party enjoys the same level of power over that country's affairs, albeit without the gray Mao Zedong suits of yesteryear. Afghanistan is rebuilding after years of Soviet occupation, civil war and recovering from Taliban rule. The Chernobyl nuclear exclusion zone is, after thirty years, showing signs of life. Although wilderness and animal populations are exploding, the elements that were spewed into the environment in 1986 will continue to linger for thousands of years. Despite this danger, more than one hundred Ukrainian

citizens call the nuclear exclusion zone home. Each of these Cold War legacy countries has been on my travel list the past several years, as I wanted to see these regions for myself and connect with the countries I watched, read and heard about as a child growing up in the Cold War era.

COLD WAR REMNANTS

What remains of ammunition plants around the country continues to be an environmental headache, but progress has been made converting many of these sites into usable recreation areas. In recent years, the Badger Army Ammunition Plant in Sauk Prairie has been cleaned up and is used for hunting as well as hiking and biking. The Badger plant has seen the same fate as other arsenal sites around the country, such as the Joliet Army Ammunition Plant in Illinois and Rocky Mountain Arsenal in Denver, Colorado. Restoring native vegetation and wildlife has also been a priority.

Skeletal remains of Wisconsin's Nike missile sites exist in the Milwaukee area. Hillcrest Park, the former fire control area of M-74 Waukesha, has radar structures and two Nike-era buildings still standing after being closed since 1970. The missile pits located two miles away from the first control area have been filled and cleaned up by the Army Corps of Engineers. Park planning is slated to make recreational use of the former missile site as of this writing. The remaining missile sites in the Milwaukee area have been converted into different entities: a synagogue, parkland storage, a machine shop and even one on private land enduring subdivision development, among other uses.

INTERSTATE HIGHWAY SYSTEM

The Cold War is also with us in other ways, without even recognizing the origins. Commuters groggily awake and take the freeway to work daily. The Interstate Highway Act in 1956 foresaw building a high-speed road network to absolve commuting problems but also had military uses and civil defense in mind. President Eisenhower, who advocated and signed the bill into law, was concerned about evacuation in the event of military attack, especially that of an atomic bomb dropped on major population centers.[77]

GPS

We can also readily access global positioning systems (GPS) on our smartphones. At the touch of our fingertips, we can have the quickest route mapped out for us, avoiding traffic jams and optimizing our rush-hour routes to avoid being late, whether for work or just inconvenience. GPS was a creation of military communications as the space age came to be in the 1960s. Roger Easton, the father of GPS, was instrumental in writing the proposal for the United States Naval Research Laboratory for Project Vanguard, America's fateful response to Sputnik. The U.S Patent Office received his submittal, "Navigation System Using Satellites and Passive Ranging Techniques," and on January 29, 1974, it was assigned U.S. Patent 3,789,409.[78]

THE INTERNET

The Internet has revolutionized the capabilities for information and communication on a scale never imagined. Its roots, however, lie in the Cuban Missile Crisis. During the thirteen-day standoff between the Soviet Union and United States over missiles erected in Cuba, there was concern about real-time information on nuclear capabilities. After a series of stages convincing universities to start networking, ARPANET (Advanced Research Projects Agency Network) was created for such a task, eventually giving way to personal computing.[79]

EPILOGUE

THE COLD WAR ABROAD

VISITING COLD WAR "BATTLEFIELDS"

Countries with enduring legacies of the Cold War are available to be toured if one so chooses—legally and without hassle if through the proper channels. Unlike tours of American Civil War battlefields or World War II sites in Europe, there is no itinerary connecting Cold War sites at home or abroad. Striking out on your own is a rewarding experience to visit such places. Needless to say, North Korea, Chernobyl and Afghanistan aren't exactly popular tourist destinations. They are places on the globe that are not considered friendly to westerners, let alone Americans. State Department warnings will be the first clue that these are not a typical family-friendly vacation sites. Each had areas of Wisconsin connections, past and present, that added to the allure of visiting and seeing firsthand.

My road of discovery searching for the Cold War brought me to these unusual, unlikely places in the world that do not appear on the bucket list of travels for just anyone. I have traveled to a variety of countries that have simultaneously made people feel awe and cringe out of fear for my safety. Family members and loved ones have pleaded for me not to go on these journeys into dangerous territories, some of which call for war or actively engage in war with the United States. Looking out to the world as a child of the era planted the wonder and motive to explore such countries, combining passions of history and competitive running while searching for this Cold War that simply disappeared when the Soviet Union fell apart. As such, these passions have created extraordinary opportunities to experience cultures that very few people can or will.

Running had long been a passion since high school, and in all honesty, it saved my life. Running competitively allowed for focus and motivation to attend school. I was truant so often that an expulsion hearing took place my junior year of high school. That spring I joined the track team and started racing the mile. Six months later, as the Berlin Wall was about to fall, I qualified for the first of two consecutive years of state cross-country championships at Janesville Craig High School. Running allowed me to finish high school, attend college and push me to the family and life I enjoy today.

Fast-forward to my late thirties, and stepping up training for masters level track and field, where thirtysomethings up through centenarians continue dialing back the clock while competing in the United States and abroad. Since 2012, I have represented Team USA at masters level championships four times on three continents: North America, Europe and Australia. The fourth continent was to be on my own in Asia, however, since any symbols representing the United States of America would likely have one imprisoned or marked for ransom. I had decided to race in the Pyongyang Marathon in Pyongyang, North Korea, in 2015. It is here I would come face to face with the reality of the Cold War in present form.

ON THE ROAD TO NORTH KOREA

I had no inclination that travels would take me inside North Korea and more. My first USA race took place in Finland, a country on the doorstep of Russia, experiencing all the heartache and pains of being on the front lines of the Cold War. That visit would include a side trip into St. Petersburg, Russia, formerly known as Leningrad. There I would find myself inside the country that was archrival of the United States and the West during the Cold War.

St. Petersburg was a crown jewel, as described. On a brisk April day, I arrived in the city that the czars once ruled, abdicated last by Czar Nicholas II in 1917. The city is home to several palaces, including the Winter Palace, which was transformed into the Hermitage Museum. It was there that the Soviets would upkeep this palace to show how royal opulence was keeping the rest of the country's citizens downtrodden. After all, under communism, everyone theoretically owned everything (paradoxically equal to owning nothing at all). The czarist family's fate was sealed in Yekaterinburg in 1918

while under house arrest. The execution of the royal family was partly a reaction to Czech legionnaire troops fighting their way along the Trans-Siberian Railway to Vladivostok during the Russian Civil War, one of the aims of the Allied Intervention into Russia in 1918–20. As noted in the first chapter of this book, troops from Wisconsin played an integral role in allowing for the safe passage of the Czech Legion fighting their way out of Bolshevik Russia. As they approached Ekaterinburg, there was fear that the Czechs would free the czarist family and restore the royal name back to power. Thus, it was decided the czar and his family should be executed. The Czech Military History Museum in Prague tells the story of Czech involvement during the Russian Civil War and subsequent horrors under Soviet domination throughout most of the twentieth century.

HUNGARY, GERMANY AND CZECH REPUBLIC

My second foray into the Cold War legacy countries would occur just two years later in 2014. I ventured into a second world indoor meet in Budapest, Hungary, site of the 1956 Hungarian Revolution, which had been quashed by Soviet troops. The Hungarian Revolution would set the tone for other uprisings across Central Europe over the next decade, with the Soviets also rolling the tanks into major centers of Prague and Warsaw. My journey would take me into the heart of what is now called the Czech Republic, visiting Prague before continuing to Budapest and viewing the history of the Czechs' struggles with the Soviets. The Czech community shares a special connection in Wisconsin, with traditional polka dancing a staple of celebrations, as well as kolaches, a type of pastry.

While at the track meet in Pest (Budapest is split along the river, with Buda on one side and Pest on the other), it was an odd feeling warming up with other athletes on a warm spring day on an outdoor track that the communists had built decades before. While the indoor track was modern, the outdoor track was made of cinder, situated by a dilapidated outdoor communist-era stadium. My trip would commence with a visit to Berlin, strolling along the avenues of what was East Berlin as that portion of the city was undergoing many renovations twenty-five years after the fall of the Berlin Wall. Tens of thousands of American military personnel were stationed in West Berlin during the Cold War, facing the reality of Soviet and East German encirclement on a daily basis.

Epilogue

There are reminders aplenty in Berlin of the divided city, most notably the partitions of Berlin Wall near the Brandenburg Gate. One can visibly see the markings of the wall itself still ingrained on the ground throughout the city as well, running along its own path—as the markings have no bearing on current establishments, buildings or throughways of the city. There are also monuments and memorials to the victims of tyranny under not only the Nazis but also the communists. Another memorial pays homage to the victims attempting to cross the Rhine River to the West who did not survive the attempt to freedom. The time displacement from the fall of the Berlin Wall has caused misunderstanding of the era by younger generations.

Take, for example, a story I was told of a group of students from western Germany that had visited Berlin a few years before my own visit. While walking around the former divided city, a young student had a perplexing question about the city's past: "Why was the Brandenburg Gate built so close to the Berlin Wall?" Much to the chagrin of the tour leader, it was explained that the Brandenburg Gate was completed in 1791, some 170 years prior to the Berlin Wall being erected around the city.

DESTINATION DANGER: NORTH KOREA

While returning from Berlin, it was reported that North Korea was allowing non-professional amateur competitors in the Pyongyang Marathon for the first time in 2014. Sensing an intriguing opportunity, I entertained the idea of going into a country that was a serious travel risk. North Korea was the penultimate Cold War legacy country to visit, and the competition was a way inside. Coupled with the fact that a Wisconsin-born ship called the USS *Pueblo* was still being held in Pyongyang, the trip was mighty appealing on a variety of levels.

The Korean War has been called the "Forgotten War," likely because many people are rightly fascinated and focused on the plethora of writings about the American Civil War, Second World War, Vietnam War and recent conflicts in Iraq and Afghanistan. More than 36,000 American military casualties resulted from the United States' involvement in the Korean War. According to the Wisconsin Veterans Korean War Memorial, the Korean War took 801 casualties among Wisconsin military personnel from June 25, 1950, through July 27, 1953; 84 are still officially listed as

Epilogue

Missing in Action.[80] Remains of at least one soldier, who fell at the battle of Chosin Reservoir in North Korea, had been returned in 2018 due to the thaw in relations between the United States and the DPRK. For the divided peninsula of Korea, the Korean War is very much still alive for its inhabitants. The heavily fortified Demilitarized Zone (DMZ) divides North and South. Roughly 50,000 American troops are stationed in South Korea at any given time, along with air and sea power to match. It is safe to say the Cold War is also still very much a reality for both North and South Korea.

Koryo Tours was the official tour operator to book with in 2014 and raised enough funds to cover a flight to Beijing in August. China afforded the opportunity to add another important Cold War legacy country on my travel list. The North Korea trip was fraught with frustration, however, as the Ebola scare of 2014 kicked into effect that October, only a few months after booking a flight to Beijing. Ebola was cited as a reason for shutting down the North Korean border and further isolating that country from the rest of the world. Few visitors made the journey into North Korea as it was. It turned out that the border wouldn't be open until six months later. During that time, the Pyongyang Marathon was canceled and subsequently reopened to foreign competitors after the border allowed passage in February 2015. A trip nearly written off as a loss (at best a visit to China would suffice) was now back on. Additional paperwork, payments and travel plans were hurriedly in place before I departed on April 8, 2015.

After a brief pre-trip preparation meeting at the tour headquarters in Beijing, the flight departed early in the morning smog aboard Air Koryo, the North Korean state airline. More than 250 trip members took the flight into Pyongyang, along with what were presumed to be businessmen, diplomats and other Chinese or North Korean government representatives. The stewardesses were polite, yet I noted the number of pilots aboard the aircraft was unusually large. Like most airlines, a newspaper of record was extended to passengers. This issue was dedicated to Kim Jong-un's visit and inspection of a fishery. During the flight, the in-flight entertainment on the television screens featured tributes to the late founder, Kim Il-sung.

After a nearly two-hour flight into Pyongyang, the aircraft landed at the airport. I had landed inside one of the most reclusive countries in the world—my first visit to a Cold War legacy country that continues to embrace the Stalinist Cold War parameters of the era. The airport was under renovation at that time, but the facilities were adequate. As we disembarked the aircraft on an overcast morning, news cameras from a North Korean state television crew filmed our arrival. We were visiting for the Pyongyang Marathon, but

Epilogue

our arrival also coincided with two important dates in their history. April 9 was the third anniversary of the current leader Kim Jong-un's election as chairman of the Korean Workers Party. It was a leadership position that cemented his power in North Korea.

Several days, later April 15 was also a celebratory date: the birthday of founder Kim Il-sung, the current leader's grandfather. We would see his likeness on walls, murals, statues and television screens all over the city. In addition, the accomplishments and footage of Kim Il-sung were further celebrated on hotel screens and state-run television stations around the clock.

Upon arrival, the large group was separated into subgroups of roughly twenty-five tourists each, after which we boarded a coach bus and drove to the hotel in Pyongyang. The initial reality set in seeing hundreds of uniformed troops undertaking their tasks around the city. Teams of soldier-workers were laboring on construction projects on sites. The city of 3 million people on a Saturday morning was sparse by all accounts. Very few cars were on the road, with little to no activity to be seen save for pedestrians walking along the city streets, many on bikes. It wasn't until later that afternoon while touring the city that the group visited the subway system, where most of the residents appeared.

That first day also saw us visit the stadium where the Pyongyang Marathon race would start and finish one day later. Video footage over the years has purported to televise executions inside this stadium; this time the stadium would play host to a marathon. Outside the stadium stood a slightly larger replica of France's Arc de Triomphe, here a symbol of victory over the Japanese occupation of over thirty-five years from 1910 to 1945. There was no mention of America's involvement liberating the Korean peninsula of Japanese military occupation during the Second World War. It was a landmark that would serve as the finish for the 10K athletes.

The food was bountiful at the hotel, which also featured a small casino in the basement run by an outfit from Macau. A small bookstore was also on the premises, featuring such works as Kim Jong-il's thoughts on the environment, non-aligned nations and athletic activities, among a variety of topics. No photos were allowed of the books. Kim Jong-il was the current leader Kim Jong-un's father, who took charge of the country in 1994 until passing away in 2012. His likeness is seen around the city, as well as on various statues, murals and pins denoting Communist Party membership, along with his father Kim Il-sung.

On Saturday, the race day began. It was a quick turnaround for the race itself, so there was no training necessary on day one. This racecourse

Epilogue

would be the only time we could be without our guides, heretofore strictly necessary during our stay in North Korea. The existing itinerary kept us entertained and busy enough, so there was no need to go off the beaten path while in the country. The racecourse itself was 10K per lap around the city. One lap was enough for me, especially for a miler such as myself as a "distance" race would have it. The course took us along the streets lined with citizens of Pyongyang. Groups of schoolchildren occupied several spots on the course and cheered us on, with many saying "hello" and giggling before running away. The runners slapped high fives with those cheering us on, with many bystanders taking pictures and others gazing down from the balconies where residents were clapping.

As participants were making their way to the starting line in Kim Il-sung Stadium, the crowd gave a raucous welcome to us. The stadium was at capacity, filled with approximately fifty thousand people. The North Koreans had been bused in to watch the race, provide visitors a genuine welcome and spectate on soccer matches taking place in the stadium during the marathon event. As we made our way to the start line, the spectators rose and made noise from their partitions. Walking to the next section, that group cheered us on and made noise with rhythm sticks or drums, all led by a cheerleader of sorts who shouted through a megaphone to rile up their section. It was quite the welcome.

Upon finishing at the Liberation Monument, the junior tour guide happily exclaimed that I had finished in second place in the 10K race. I had no expectation going into the event since, as mentioned, my last road race had felt like an eternity ago. Several of our subgroup members medaled or won their respective marathons or half marathons, which was a pleasant surprise. An award ceremony took place later that evening, along with a banquet, as medals were placed around respective winners, trophies given and posters and shirts awarded from Koryo Tours.

On day three in Pyongyang, our small group took a longer day tour of the city. We started out by visiting the vaunted statues of Kim Il-sung and Kim Jong-il, with the tour guide placing flowers at the base of the statues. It was said that there is no statue honoring Kim Jong-un out of deference to his mother while she is alive. On behalf of the group, the tour guide took a bow out of respect toward the statues as well. Next up, we visited the birthplace of Kim Il-sung, where the tour guides explained the rise of the country's founder from humble origins in the countryside to leading the nation. Kim Il-sung was responsible for leading the partisan warfare aimed at driving out the Japanese during the Second World War.

EPILOGUE

Finally, we arrived at the Victorious Fatherland Liberation War Museum. A museum guide showed us around the exterior of the building first, discussing captured or abandoned American weapons on exhibit from the Korean War. Naturally, she emphasized the North Korean version of events during the conflict from 1950 to 1953. At no point during our visit was Soviet or Chinese assistance of North Korean forces during the war mentioned.

BOARDING THE USS *PUEBLO*

Another primary reason for visiting North Korea was to go on board the Wisconsin-built USS *Pueblo*. The *Pueblo* was an American information-gathering vessel captured in international waters in 1968. Eighty-three crew members were attacked on the morning of January 22, 1968, under heavy artillery fire. One crew member died, while eighty-two (two were civilian oceanographers) were held captive for eleven months (see chapter 9). The ship serves as a symbol of prestige in North Korea, which uses it to claim victory over the imperialist and capitalist warmongering United States. To its credit, the ship has been refurbished and cared for as a museum, with exhibits of crew members' possessions and articles of the ship. Walking on board, I could only sense the terror and uncertainty overcoming crew members during the surprise attack. The crew was captured, placed on trial and imprisoned until December 1968.

Next up, we entered the Victorious Fatherland Liberation War Museum building and were instructed not to take any photographs of this multimillion-dollar establishment. It was a proud achievement, according to the tour guide, as this impressive and modern military museum was completed in a mere eleven months. It was also said that Kim Jong-il visited the museum personally at its inception and gave his blessing to its features. Once inside, we were immediately greeted by a large, colorful two-story statue of a young Kim Il-sung in military dress. We were told to bow out of respect before climbing the red-carpet stairwell.

The group sat down to view an introductory video displaying how the Korean War began. The "big three" leaders at Yalta in their version of the film featured only Harry Truman of the United States and Clement Attlee of the United Kingdom. Noticeably absent was Josef Stalin, who along with the Chinese leader Mao Zedong gave considerable aid to the

early North Korean government led by Kim Il-sung, whose namesake the Victorious Fatherland Liberation War Museum graced at every turn. Black-and-white footage showed women and children peacefully picking flowers when, suddenly and without warning, the Americans invaded North Korean territory with great firepower. After the video, we were taken to another wing of the museum, which offered a spectacular 360-degree viewing platform of a battlefield panorama during the Korean War. Emphasis, predictably, was placed on the transgressions of the United States Army during the war. Exhibits also included several dog tags of American GIs that were not returned to the United States after hostilities under a treaty signed in 1953. Despite some glaring biases on display, I left North Korea without incident, pleasantly surprised and learning much through conversations with North Korean tour guides.

Finishing my tour of Asia in Beijing allowed a visit to Tiananmen Square, famous for the 1989 demonstrations taking place against the communist government. The photograph depicting the man in front of the tank will forever be etched in the annals of history of communist tyranny over the people. An oil portrait of Mao Zedong hangs over the large public square. The painting is retouched every year after weather erosion.

RADIOACTIVE HISTORY: CHERNOBYL, UKRAINE

With travels to Central Europe, Russia and Asia under my belt, my sights were set on a location that common sense would dictate people just do not visit due to safety: Chernobyl. Common sense apparently is not a trait that I have been blessed with when it comes to travel. Given radioactive elements that are forecast to survive for some twenty thousand years, the situation would normally prompt caution. Tour reviews and information on the Chernobyl nuclear exclusion zone were reassuring, however, and I sought to be part of the thirtieth anniversary of the nuclear explosion, which took place in 1986.

The town of Chernobyl is about ten miles south of the reactor sites. However, being the principal town near the Chernobyl nuclear plants, its name was assigned to the nuclear reactor sites established in 1970. Chernobyl is a beautiful natural area akin to Wisconsin. Plush vegetation, trees, foliage and the blue water of the Pripyat River would fool any person unaware of the history of the area. If it were functioning without its ominous and dangerous

past, the area would be utilized as a resort destination for camping, hiking, water sports and fishing. Instead, Chernobyl's fate would be as the world's worst nuclear disaster site.

Four reactors were online when the Chernobyl incident took place. A fifth reactor was nearly 80 percent complete when disaster struck. Reactor no. 4 was the subject of a test on the evening of April 26, 1986, when steam contributed to an explosion of epic proportions. Remarkably, only one person died as a direct cause of the explosion. Other immediate deaths would harshly befall emergency response personnel and firefighters, called "liquidators." Dozens perished immediately as they doused the flames, provided medical care and assessed the situation. All of those responding to the eruption perished, with scant understanding exactly what they were fighting. Today, visitors can come within about two hundred feet of reactor no. 4, just outside the fence line guarding the reactor. The original sarcophagus placed on the reactor after the explosion was replaced a few short months after the visit, several years overdue and overbudget.

MILWAUKEE CONNECTION TO CHERNOBYL

In response to the Chernobyl incident, President Ronald Reagan offered humanitarian assistance to the Soviets. The Soviet Union rebuffed the offer. Clearly, there was a need for medical assistance to such a disaster. In response, the Medical College of Wisconsin, headquartered in nearby Wauwatosa, sprang into action.

Dr. Mortimer Bortin had maintained an International Bone Marrow Transplant Registry at the medical college.[81] He and a team of doctors assisted patients inside the Soviet Union and saved many lives as a result.

About 49,000 residents of the nearby town of Pripyat, which was the domain of mainly workers and their families at the nuclear plants, were left largely unaware of the explosion and subsequent radiation falling on them. It took a full three days for an evacuation plan to materialize. Most were housed with other families in areas just outside the nuclear exclusion zone. Some 1,200 residents made their way back into the nuclear exclusion zone, where their houses and possession lay. As of this writing, nearly 100 individuals continue to live in the zone. They are supplied by delivery services about once a month and offered an opportunity to socialize with others via bus transport to a central location

Epilogue

within the zone. While there, they can sell or barter their wares, knitting and the like.

Fortunately, our tour group met a woman named Maria, who was eighty-eight years old. Maria greeted our small group at the front door with an armful of green beans freshly picked from her garden. She was a persistent woman who made her way back in 1987 after being unhappy with the people she was placed with after the evacuation. She could take backwoods trails to her home, pathways that she and family members used during the Second World War. During the war, Maria was a teenager, burying dead soldiers of the Soviet Union and Nazi Germany, depending on which side had the upper hand at any given time. Dating back to the 1930s, she survived brutal starvation schemes in the Ukraine by the Soviet Union as a child. After surviving the Second World War, Maria withstood the Soviet Union's continued dominance of Ukraine throughout the Cold War, only to be challenged by the Chernobyl nuclear disaster in 1986.

Pripyat is a ghost town today. Those who are enamored of zombies undoubtedly watched the movie *Chernobyl Diaries*, in which the living dead infest the nuclear exclusion zone and feed off any unsuspecting tourists wandering into their domain. My daughter was convinced that upon visiting the theme park, I would end up a rotisserie chicken on the Ferris wheel. I stood near the ticket box office and bumper cars tempting fate, but alas, there was no sign of zombies. The park had only been open to employees and their children for three days before disaster struck. The park is eerily stuck in time in 1986, just like the rest of Pripyat.

The city of Pripyat was a modern example of the new Soviet city. Upscale shopping, modern hotels and updated flats for its residents were just some of the hallmarks. The city itself was a concrete fixture in the middle of the plush environment. Viewing a documentary that had footage of the era, I could see that little to no trees or foliage existed in 1986 before the nuclear disaster. However, today, nature is fighting back to reclaim its rightful place. Trees have taken over stadiums, buildings and roads in some areas, as well as growth seen on top of the nuclear reactors. Buildings are dilapidated and crumbling due to the elements. Schoolhouses, hospitals, grocery stores and other buildings lie in near ruin. Radiation can be detected on a Geiger counter placed near the base of houses. During the disaster, water hoses were sprayed on roofs to cleanse the houses of radiation. The radiation then settled at the base.

Entire villages were razed. Rusted boats can be seen on the Pripyat River. Trains are stopped in time on railroad tracks, and junkyards full of vehicles used during the containment effort are commonplace. Soviet propaganda

lines the walls of buildings. Many posters are heaped like trash in multiple rooms. On the outskirts of town, collective farms stand still in time. Threshers, tractors and vehicles are frozen. Small homes are reminiscent of families living there, as one can view coats on hooks and dinnerware set at the table as if meals are ready to be served.

Outside Pripyat, we visited a top-secret radar base called Chernobyl-2. Only those with a need-to-know clearance were aware of its existence. Its mission was to detect United States and NATO activity such as aircraft, bombers, space and satellite launches and missiles. The resource used was a one-thousand-foot-wide, four-hundred-foot-tall DUGA (ARCH) Radar system. When disaster struck, the base was abandoned. The base now lies in ruins like other previously inhabited areas.

NUCLEAR HISTORY OF WISCONSIN

Three main reactors operated in Wisconsin during the Cold War. The first was the La Crosse Boiling Water Reactor, built in La Crosse, Wisconsin, along the banks of the Mississippi River. Operational in 1971, the LACBWR closed in 1987, one year after the Chernobyl nuclear disaster. Two nuclear reactors were built along Lake Michigan during the same era. Kewaunee Power Station was operational in 1973 and shut down in 2013, and Point Beach Nuclear Plant in Two Rivers was fully operational in 1970. It continues to provide power generation to more metropolitan areas of Green Bay, Appleton and the Fox Valley, as well as transmission lines to Milwaukee. The Zion Nuclear Generating Station is a few miles south of the border of Wisconsin, while the Byron Generating Station is forty miles south of the border.

COULD A SIMILAR CHERNOBYL INCIDENT OCCUR IN WISCONSIN?

Overall, nuclear power has been proven to be a safe, clean technology while operational. The aftereffects of what to do with spent fuel rods in Wisconsin and other areas of the United States and the world will continue to present challenges for safety and ecological concerns. There are certainly hazards that have proven destructive, such as in the Fukushima accident in Japan

in 2011, and other close calls, such as Three Mile Island in Pennsylvania in 1979. To be sure, the design flaws in the Chernobyl nuclear plants, added to the de-emphasis of safety versus output results, are not present in American nuclear reactors. The effects of the Chernobyl explosion and the surrounding exclusion zone may be harmful for large-scale habitation for up to twenty thousand years. Despite this, there continues to be people who have lived in the zone for decades without any issues. These individuals breathe the air, eat foods grown in gardens and use water from the surrounding area. Due to human inactivity in the 2-600-square-mile exclusion zone, the area is also teeming with wildlife and forest growth, displaying its natural beauty. Thus, if a reactor were damaged in Wisconsin or Illinois, it would affect a wide range of the region.

AFGHANISTAN

The Soviet invasion of Afghanistan occurred during a precarious series of events in international relations in 1979. It followed the taking of American hostages in Iran the month before and the communist Sandinistas taking power in Nicaragua before that. The Soviet-Afghan War raged on for a decade until 1989. Immediately after the invasion, a resistance formed and the CIA sent cash and stinger missiles to aid the Mujahideen, taken from the word *jihad* (struggle). Soviet troops would eventually pull out as the Berlin Wall fell and the Soviet Union was soon to collapse entirely. Incidentally, Soviet helicopters and pilots would be recalled from Afghanistan during the Chernobyl disaster. Pilots were needed to douse the flames of the explosion in 1986, further weakening the ability to wage war in Afghanistan. Following the Soviet withdrawal were civil wars and Taliban control, eventually leading to heavy American involvement after 9/11.

To see this Cold War legacy country, I arranged to compete in the Marathon of Afghanistan in 2017. Most of the trip took place in Bamiyan in the central Afghan highlands, home to the largest standing Buddha statues in the world. In 2001, the Taliban destroyed them, unsuccessfully launching missiles at them at first but ultimately destroying these remarkable statues with dynamite. Today, the statues are awaiting reconstruction, with many of the original pieces recovered and sitting at the base of their longtime presence in the mountainside.

Epilogue

Flights originated from and returned to Kabul, a bustling city that captivated minds, as we witnessed rush-hour traffic that consisted of vehicles, motorcyclists, bicyclists, pedestrians and horse- and donkey-drawn carts occupying the same roadways. Very few stoplights or even street signs existed, but somehow it worked. Eating a traditional dinner of kabobs and rice the first day, the group could hear rapid-fire guns and RPGs in the mountainsides. I was a long way from home. In a stunning contrast, the area north of Bamiyan in Band-e Amir National Park demonstrated the country's beauty, full of life and majestic landscapes. This national park had five crystal-clear blue lakes, waterfalls and hiking trails that are unimaginable considering the news reports about terror at the capital.

Soviet remnants remained around the country. Dilapidated tanks can be found inside and outside Bamiyan. The Omar Landmine Museum in Kabul has not only a wide variety of landmines but also Soviet helicopters, fighter jets and armaments. America's most famous contribution, other than cash for the Mujahideen, were stinger missiles. Only a stinger missile case was found in the museum, as we were told that all stinger missiles were returned to the United States since many were finding their way into the hands of people who should not have them. Our group was able to sip tea and chat with a Tajik Mujahideen commander who had retired and was now selling quality afghan rugs on Chicken Street in Kabul. The man, Alloh, was the true Rambo of his time, standing all of five feet, eight inches, jumping out of water and bushes and throwing grenades, rocks, sticks or whatever was lying around at the invading Soviets. Much of Kabul has been rebuilt since coalition forces invaded Afghanistan. A durable people, Afghanis continue to survive amid strife and violence, adapting as best they can to whatever comes their way.

The Cold War Museum is dedicated to continuing education and preservation efforts of the era. To learn more or become involved visit www.coldwar.org.

NOTES

Chapter 1

1. Bill Streifer and Irek Sabitov, "The Flight of the Wild Hog: The Day the World Went Cold," *Forbidden Archaeology*, http://forbiddenarchaeology.blogspot.com/2012/11/the-flight-of-hog-willd.html#!/2012/11/the-flight-of-hog-willd.html.
2. Long Telegram, George Kennan, National Security Archive, https://nsarchive2.gwu.edu//coldwar/documents/episode-1/kennan.htm.
3. Robert Service, *Comrades!: A History of World Communism* (Cambridge, MA: Harvard University Press, 2007), 2.
4. Benjamin Rhodes, *Wisconsin's War Against Russia*, University of Wisconsin–Whitewater, Wisconsin Academy of Arts, Letters, and Sciences, vol. 72 (n.d.), 66, http://images.library.wisc.edu/WI/EFacs/transactions/WT1984/reference/wi.wt1984.bdrhodes.pdf.
5. American Intervention in Northern Russia, 1918–1919, Polar Bear Expedition Digital Collections, https://quod.lib.umich.edu/p/polaread/history.html.
6. John Cudahy, *Archangel: The American War with Russia* (Chicago: A.C. McClurg & Company, 1924), 61–74.
7. Ibid.
8. E.M. Halliday, *When Hell Froze Over* (New York : Simon & Schuster, 2000), 13–14.

9. George Kennan, *Soviet Foreign Policy, 1917–1941* (Huntington, NY: R.E. Krieger Publishing Company, 1979), 20.
10. *Tuscaloosa News*, "Five Michigan Buddies Hunt Bodies of Buddies," September 12, 1929.
11. American Legion, https://www.legion.org.
12. John Scott, *Behind the Urals: An American Worker in Russia's City of Steel* (Bloomington: Indiana University Press, 1942).

Chapter 2

13. Operation Unthinkable, https://web.archive.org/web/20101116155514/http://www.history.neu.edu/PRO2/pages/002.htm.
14. The Long Telegram, as described in John Lewis Gaddis, *George F. Kennan: An American Life* (New York: Penguin Books, 2011), 201–22.
15. *Foreign Affairs*, "The Sources of Soviet Conduct" (July 1947).
16. Open Society Archives, "A Look Back at the Marshall Plan," June 1987.
17. Peter Grose, Operation Rollback: America's Secret War Behind the Iron Curtain (N.p.: Mariner Books, 2001), 117.
18. Oral history contributed by George Georgie's granddaughter, Jill Fuller.
19. Grose, *Operation Rollback*, 204.
20. Lisle A. Rose, *The Cold War Comes to Main Street: America in 1950* (Lawrence: University Press of Kansas, 1999), 49.
21. Grose, *Operation Rollback*, 205.

Chapter 3

22. *Milwaukee Sentinel*, "Police Chief Shot Dead After Refusing Red Rule," May 2, 1950, 2.
23. *Milwaukee Journal*, "Mosinee in Hands of Reds After Make Believe Coup," May 1, 1950, 1–2.
24. Philip S. Foner, *May Day: A Short History of the International Workers' Holiday, 1886–1986* (New York: International Publishers), 41–43.
25. Rose, *Cold War Comes to Main Street*.
26. *Milwaukee Journal*, "Leaders of Red Coup Well Fitted for Chore," May 1, 1950, 1.
27. *Wisconsin State Journal*, "Communism for a Day: A May Day Remembered in Mosinee," May 1, 2014.
28. *Milwaukee Sentinel*, "Mosinee Mayor Near Death After Day Under 'Reds,'" May 2, 1950, 1.

29. Richard Fried, *The Russians Are Coming! The Russians Are Coming! Pageantry and Patriotism in Cold War America* (New York: Oxford University Press, 1999).

Chapter 4

30. Thomas C. Reeves, *The Life and Times of Joe McCarthy: A Biography* (N.p.: Madison Books, 1997), 112.
31. Arthur Hermann, *Joseph McCarthy: Reexamining the Life and Legacy of America's Most Hated Senator* (N.p.: Free Press, 1999), 97.
32. United States Army Communications Electronics Life Cycle Management Command, "A History of Army Communications and Electronics at Fort Monmouth, New Jersey, 1917–2007," Historical Office, 2008, 35.

Chapter 5

33. NASA Space Science Data Coordinated Archive, https://nssdc.gsfc.nasa.gov/nmc/spacecraftDisplay.do?id=1960-005A.
34. James C. Spry, "Death of Sputnik IV: Main Street U.S.A.," *Civil Service Journal* (April–June 1963).
35. Warren C. Wetmore, "U.S. Analysis Reveals Sputnik 4 Fabrication Techniques," *Aviation Week*, December 3, 1962.
36. Matthew Brzezinski, *Red Moon Rising: Sputnik and the Hidden Rivalries that Ignited the Space Age* (New York: Times Book, 2008), 36.
37. Ibid., 95.
38. Ibid., 147.

Chapter 7

39. Flight Safety Foundation, Aviation Safety Network, https://aviation-safety.net/wikibase/wiki.php?id=48304.
40. *Milwaukee Journal Sentinel*, "Map Librarian Finds 1966 Crash Site," August 29, 2016, https://www.jsonline.com/story/news/local/2016/08/29/map-librarian-finds-1966-crash-site/89303126.
41. B-47 Stratojet Association, https://b-47.com/?page_id=1174.
42. "B-52 Crash, Inver Grove Heights, MN." Reprinted with permission from Noel Allard.

Chapter 8

43. Rosemary Sullivan, *Stalin's Daughter: The Extraordinary and Tumultuous Life of Svetlana Stalin* (New York: HarperCollins, 2015), 286.
44. Svetlana Stalin, *Twenty Letters to a Friend* (New York: HarperCollins, 1967), 184.
45. Sullivan, *Stalin's Daughter*, 127.
46. Nicholas Thompson, "The Complicated Life of Svetlana Alliluyeva," *The New Yorker* 90, no. 6 (March 31, 2014).
47. Ibid.
48. Sullivan, *Stalin's Daughter*, 127.
49. *Milwaukee Journal Sentinel*, "Stalin's Daughter Dies, Had Lived in Richland Center," http://archive.jsonline.com/news/obituaries/stalins-daughter-dies-had-lived-in-richland-center-j837ubs-134628588.html.

Chapter 9

50. Jack Cheevers, *Act of War* (New York: Penguin Group, 2013), 57.
51. USS *Pueblo* Veterans Association, http://www.usspueblo.org/Background/Ship_History.html.
52. Thomas R. Johnson, *American Cryptology during the Cold War, 1945–1989*, vol. 2, *Centralization Wins, 1960–1972*, monograph (Fort George G. Meade, MD: Center for Cryptologic History, National Security Agency, 1995), 439.
53. Cheevers, *Act of War*, 62–77.
54. Ibid., 87–88.
55. *Naval History Magazine* 28, no. 5 (October 2014), https://www.usni.org/magazines/navalhistory/2014-08/pueblo-scapegoat.

Chapter 10

56. Recollections from Werner Juretzko, shared with the author.
57. John Van Altena, *A Guest of the State* (N.p.: Neville Spearman Limited, 1968).

Chapter 11

58. Taken from the Bible Gateway, https://www.biblegateway.com.

Chapter 12

59. Rose, *Cold War Comes to Main Street*, 223.
60. *Milwaukee Journal Sentinel*m, "Douglas MacArthur Comes 'Home' in 1951," http://archive.jsonline.com/greensheet/douglas-macarthur-comes-home—in-1951-b99711831z1-377187451.html.
61. *New York Times*, "Nicaragua Downs Plane and Survivor Implicates C.I.A.," October 12, 1986; December 12, 1986, https://www.nytimes.com/1986/12/12/world/hasenfus-sentence-confirmed.html?mcubz=0.
62. Golda Meir, *My Life* (New York: G.P. Putnam's Sons, 1975).
63. Milwaukee Public Schools, "History of Golda Meir School," http://www5.milwaukee.k12.wi.us/school/goldameir/about/history.

Chapter 13

64. *Baraboo News Republic*, "Aftershocks: Local Ties to Sterling Hall Bombing Remembered," October 28, 2014, http://www.wiscnews.com/baraboonewsrepublic/news/local/aftershocks-local-ties-to-sterling-hall-bombing-remembered/article_74da5325-7a35-5669-aeec-33e6ec66a460.html.
65. Tom Bates, *Rads: A True Story of the End of the Sixties* (New York: HarperCollins, 1992), 20.
66. *Badger Herald*, "UW's Radical Liberal Movement and the August Morning It Died," September 1, 2010, https://badgerherald.com/news/2010/09/01/uws-radical-liberal.
67. *Wisconsin State Journal*, "Dwight Armstrong, Sterling Hall Bomber, Dies at 58," June 21, 2010, http://host.madison.com/wsj/news/local/article_5a410ef6-7d8d-11df-893b-001cc4c03286.html.
68. *Wisconsin State Journal*, "Sterling Hall Bomber Armstrong Arrested After $800,000 Cash Found in Vehicle," May 22, 2012, http://host.madison.com/wsj/news/local/crime_and_courts/sterling-hall-bomber-armstrong-arrested-after-cash-found-in-vehicle/article_c5da4e80-a38c-11e1-a02f-001a4bcf887a.html.
69. Loris, "In the Matter of the Application for Admission to the Oregon State Bar of David Sylvan Fine, Petitioner," Lexis-Nexis Academic Universe, http://www.loris.net/onken/OSBFine.html.

Chapter 14

70. Bob Aldridge, *Elf History: Extreme Low Frequency Communication*, February 18, 2001, http://www.plrc.org/docs/941005B.pdf.
71. *Nuclear Register*, "Project ELF Closes," October 15, 2004, http://www.nukeresister.org/static/nr135/135elfcloses.html.
72. Lloyd H. Cornett and Mildred W. Johnson, *A Handbook of Aerospace Defense Organization, 1946–1980* (Peterson AFB, CO: Office of History, Aerospace Defense Center, 1980), 159, 64.
73. *Badger Army Ammunition Plant: Historical Overview, 1941–2006* (Rock Island, IL: U.S. Army Joint Munitions Command), http://www.jmc.army.mil/Docs/History/Badger%20Army%20Ammunition%20Plant%20-%20V3%20Internet.pdf.
74. Bill Novak, "Contaminated Badger Ammo Plant Soil to Be Removed, DNR Says," *Wisconsin State Journal*, June 18, 2013.
75. Clarence Jungwirth, *Oshkosh Trucks: 75 Years of Specialty Truck Production* (Osceola, WI: Motorbooks International, 1992), 13–18, 29–32.
76. Information provided by Virginia Tapper to the author.

Chapter 15

77. U.S Department of Transportation, Federal Highway Administration, "Highway History: Civil Defense 1955," https://www.fhwa.dot.gov/infrastructure/civildef.cfm.
78. U.S Naval Research Laboratory, "Father of GPS and Pioneer of Satellite Telemetry and Timing Inducted into National Inventors Hall of Fame," https://www.nrl.navy.mil/media/news-releases/2010/father-of-gps-and-pioneer-of-satellite-telemetry-and-timing-inducted-into-national-inventors-hall-of-fame.
79. Sharon Weinberger, "Web of War: How the Hair-Trigger Nuclear Age and Fears of Armageddon Inspired Visionary Cold Warriors to Invent the Internet," excerpted from Weinberger's *The Imagineers of War* in Aeon Essays, https://aeon.co/essays/how-nuclear-fears-helped-inspire-creation-of-the-internet.

Epilogue

80. Casualty count of Wisconsin service members, Wisconsin Korean War Veterans Memorial, http://www.koreanmemorial.org/stats.html.
81. *Chicago Tribune* via United Press International, "Bone Marrow Center in Wisconsin Gets Center Stage in Soviet Accident," May 13, 1986, http://articles.chicagotribune.com/1986-05-13/news/8602030531_1_bone-marrow-transplants-registry-success-rate.

INDEX

A

Afghanistan 9, 10, 102, 118, 133
Alliluyeva, Svetlana 76, 77
Andropov, Yuri 11

B

Berlin Blockade 15, 42
Berlin Wall 8, 9, 11, 36, 91, 94, 102
Bolsheviks 13, 17, 19, 22, 23, 24, 25
Brezhnev, Leonid 11

C

Chernenko, Konstantin 11
Chernobyl 10, 118, 129, 131, 132, 133
Churchill, Winston 17, 23, 29
Cudahy, John 19, 20

D

Day Under Communism 37, 38, 39

E

Eisenhower, Dwight 35, 45

F

First World War 17, 21, 22, 23, 25, 61

G

Goldman, Emma 26, 38
Gorbachev, Mikhail 11

H

Hasenfus, Eugene 106
Hitler, Adolf 28, 65, 87, 88
Hungary 31, 36, 123
Hurley 72

INDEX

I

Inver Grove Heights 73, 74, 75
Iron Curtain 8, 11, 17, 31, 32, 35, 36, 89, 91

J

Janesville 10, 59, 92, 98, 122
Juretzko, Werner 87, 88, 89, 90, 91

K

Kennan, George 12, 16, 30, 76, 78, 109
Kersten, Charles 35, 36
Kewaunee 12, 82, 84, 132
Khrushchev, Nikita 45, 48, 49, 56
Korean War 35, 99, 104, 114, 115

M

MacArthur, Douglas 12, 104
McCarthy, Joseph 24, 36, 37, 40, 41, 42
Meir, Golda 106, 108
Milwaukee 12, 19, 28, 30, 35, 40, 52, 56, 58, 59, 60, 65, 87, 99, 101, 102, 104, 106, 108, 114, 115, 132

N

North Atlantic Treaty Organization (NATO) 7, 132
North Korea 10, 80, 82, 84, 122, 124, 126, 127

O

Operation Unthinkable 30

P

Polar Bears 15, 17, 24
Project ELF 113
Putin, Vladimir 11

R

Reagan, Ronald 11, 106
Red Scare 17, 25, 26, 41, 42
Richland Center 79

S

Safe House 99, 100, 101, 102, 103
Second World War 8, 9, 12, 15, 16, 17, 27, 29, 30, 32, 42, 44, 48, 58, 65, 76, 77, 78, 82, 88, 99, 109, 111
Sputnik 16, 44, 45, 46, 48, 49, 50, 52, 120
Stalin, Josef 8, 17, 27, 29, 35, 76, 77, 78, 108
Sterling Hall 109, 110, 111, 112

T

Tet Offensive 80

U

USS *Pueblo* 12, 80, 81, 82, 83, 84, 86

INDEX

V

Van Altena, John 70, 92, 97
Vietnam War 65, 80, 98, 109, 110, 111, 115

W

Waukesha 12, 25, 55, 59, 61, 62, 64, 65, 115, 116
Wilson, Woodrow 18, 22

Y

Yalta Conference 15

ABOUT THE AUTHOR

Christopher Sturdevant is a children's librarian who resides in Milwaukee, Wisconsin. His interest in the Cold War began while growing up during the 1980s. Chris studied history and physics at Carroll University. He is an air force veteran and chairman of the Midwest Chapter of the Cold War Museum in Washington, D.C. In addition, Chris has represented Team USA in masters level track championships on three continents. His travels have taken him to North Korea, Chernobyl and Afghanistan.